CINDY SHERMAN

UNTITLED FILM STILLS

CINDY SHERMAN

With an essay by Arthur C. Danto

JONATHAN CAPE

LONDON

First published in Great Britain 1990
Jonathan Cape Ltd, 20 Vauxhall Bridge Road, London SW1V 2SA
© Cindy Sherman and Schirmer/Mosel, Munich 1990

The photographic material for the plates in this volume was kindly
provided by Metro Pictures, New York. All rights reserved.

A CIP catalogue record for this book
is available from the British Library

ISBN 0-224-03017-5

Reproductions: O.R.T. Kirchner & Graser GmbH, Berlin
Typesetting: SchumacherGebler, Munich
Printing: Appl, Wemding
Binding: Oldenbourg, Munich

PHOTOGRAPHY AND PERFORMANCE:
CINDY SHERMAN'S STILLS

Arthur C. Danto

Ancient art is a celebration mainly of gods and heroes, but the heroes themselves – the gods having no such choice – were moved by the poignancies of everyday life, and envied the simple pleasure of commonplace existence. Achilles, the most stunning of heroes and nine-tenths a god, turned his back upon the long peaceful life of a lordling farmer in favor of a terrible glory and a brilliant death, only because he was driven from the course of reason by emotions too overpowering even for his magnificent personality to contain. When Odysseus encountered him in the underworld, Achilles conceded his great error, and proposed that the life on earth even of a serf was to be preferred to that of a king among the dead, even if his name were forever to be synonymous with warrior splendor. And Odysseus himself, as we know from the beautiful myth with which Plato concludes *The Republic,* chose from all possible lives into which he might be reborn, a life of quiet obscurity, that of "a private man who has no cares." It must have been in tribute to that authoritative endorsement of the ordinary that James Joyce substituted for Odysseus that most human-all-too-human of personalities, Leopold Bloom – an ordinary man leading an ordinary life in a city like any other – and gave to mere daily reality, a "day in the life," the weight and dimension of an epic.

The lesson of the heroes, Joyce apart, has been a difficult one for Western art to learn, and it has addressed itself overwhelmingly to the narrative representation of saints and saviors doing marvelous redemptive things – slaying dragons, enduring martyrdom, working wonders – or of kings and queens and courtesans, or generals traversing the alps and delawares of military conquest. Only the Dutch, perhaps, cherished their own plain faces and lumpy bodies, and wanted their art to be responsive to the domestic truths of kitchen and dooryard, to the implied noise of streetlife and tavern, or the stench of the fishmarket. Even self-styled revisionists, like the Pre-Raphaelites, who damned the entire history of painting from Raphael to their own immediate predecessors as false to the visual truth of the sensed world, continued, in their actual paintings, to romanticize chivalry, magic, and mythic beauty – and they saw in the daily life of their own times, and hence in the world in which ordinary men and women lived their lives, industrial ugliness and commercial banality beyond aesthetic hope. So they set about constructing for themselves little islands of aesthetic sanctuary, enclaves of fine taste and pleasing design and revived craftmanship. And, because they were visionary and utopian, they proposed the ideal of a community of artists (which anticipated if it did not actually give rise to the "artists' colony") in which painters, weavers, and potters live as aesthetic exiles from their own world, as a form of tacit cultural criticism. It was one of the efforts of Modernism to colonize the outside world in the name of good design, and to give exhibition space in its museums to objects of daily use which embodied principles of good taste and craftmanship, the very principles of simplicity and formal purity that modern art itself aspired to. The implicit goal was to redesign the *Lebenswelt* in which ordinary persons were condemned to live amidst tasteless, ugly, tacky things, and replace it with a world of beautiful functional forms in suave composed environments.

5

There is a deep and unanswered question in social history of why, in the early 1960s, a great reversal took place, in which the objects that define the very form of life that had been routinely dismissed as aesthetically unacceptable, began all at once to swamp artistic consciousness, and to flood the precincts of high art with the energy of a profound revolution. The objects were things everyone knew and everyone understood and everyone used and enjoyed, things so dense with the meanings that compose lived culture that a person who had to inquire what they were would be alien to that culture, but at the same time so submerged in the dailiness of daily life as to be almost invisible. Who ever could have imagined the soup can or the soda bottle becoming the motifs of fine art? Or the comic strip, the numbered painting, or the advertizing image?

Things of this order of banality had, of course, in the course of the twentieth century, detached themselves from their original networks of use and meaning, and crossed over, as members of an avant-garde in the literal military sense of the term, into alien artistic territory. The aperitif label, for example, infiltrated the still-life with bottles in the early days of Cubism. It was the actual label, not even an artist's copy, and it or a piece of torn newspaper was pasted onto canvases which became instantly hybrid, objects of high art which incorporated fragments of real life. Duchamp redeemed crass advertisements for fine art by slight modifications. But it is difficult to forget the resistance to a painting by Edward Hopper, in which a rural filling station is depicted on a lonely road against brooding trees, which would have been read as a deep and characteristic lament for the isolation of American life — poetic, melancholy, elegiac — except for the sign, with the familiar flying red horse, which Hopper painted, bright and brash, against the lowering sky. The Mobil Oil sign seemed as out of place in such a painting as the actual sign itself would have been out of place in an art gallery. And then, abruptly, in the 1960s, space had been

opened up for just such emblems as it, and it could have hung alongside the Campbell Soup Can, the hamburger and the piece of pie, the enlarged lipstick, the Brillo Box, in the company of unmodified advertisements from the daily newspaper, images from billboards and the sides of delivery wagons, paintings of toothpaste tubes, ketchup bottles, ice-cream cones. And it might have occurred to someone to reflect on how reassuring it would be to see the dear old Flying Red Horse at twilight, on just such a country road as Hopper painted, when one had, in Robert Frost's words "Miles to go before I sleep" and the fuel gauge was signalling ominous signs of depletion. It would take a very powerful religious image indeed to carry the message of warmth, comfort, nourishment, security, animal happiness and the sense of at-oneness with the universe radiated by the familiar can of chicken noodle soup!

Of the signs and images of ordinary sub-artistic reality, few would be more commonplace than photographs — and few would carry a more powerful charge of human meaning. The baby picture, the graduation photograph, the mug shot on one's driver's license or passport, the wedding portrait, the honeymoon snapshots, the polaroids of the new house, the new baby, the new car condense the biographies of each of us (the death picture, which gave employment to so many anonymous painters of the nineteenth century, has not survived into our present system of pictorial markers of crucial moments in simple lives). The publicity glossy or the poster of the movie or rock star hangs like an icon on countless walls, bringing into homely rooms the incandescent glamor of transcendent beings, quite as vividly as the icon itself brought the truth of spiritual light into mean hovels and dark chambers. And the images which we instantly recognize constitute the common cultural consciousness of everyone who also recognizes them instantly: we form a cognitive and spiritual community with everyone who knows, without having to ask, which are the faces of Liz and Elvis, Jackie and Marilyn, Mickey

and Minnie and Donald, Batman and Superman, Johnson and Nixon, John and Yoko and Ringo, Jesus and Mary. Each of these images activates whole clusters of feelings and memories and attitudes which compose a form of life – and when these images are no longer instantly recognized, then, as Hegel says, a form of life will have grown old. It is not simply that these images are ourselves, but that to participate in the life of our culture is to have internalized what we might term the language of photographic forms, to be masters of the rules that define the meaning of a photograph, just as a photograph, whatever its content. Most of the photographs of common life had little to do with photography as an art or with the artistic ambitions of fine photography. And then, in the Sixties, along with the other signs and emblems, these humble images began to find their way into the space of art. They did not, as it were, follow a trail blazed by the great photographers – Stieglitz or Weston or Adams or Cartier-Bresson. It was not as though the Pop movement taught the snobbish to perceive aesthetic merit in the photography of everyday life (the way in which the old romantic movies showed the hero to recognize moral merit in the shopgirls and manicurists they elevated through marriage). Rather, it taught us to recognize the deep human essence with which these lowly images were steeped, aesthetics be damned.

Photography has suffered a form of split consciousness almost since its inception, one which parallels the split in pictorial representation between fine art and commercial art. Because photography was immediately perceived as raising a profound challenge for painting, the histories of painting and photography through the nineteenth century and into our own are complexly intertwined. Despite a powerful prejudice against the photographic image in consequence of its being mediated by a mere mechanism, which was the obverse of the prejudice which exalted the artist's hand, enough pictorial artistry was available to the photographer to justify a grudging admission that photographs could be

art: composition, the subtle gradation of black-and-white values, the exploitation of highlights and shadows, the registration of atmospheric effects, the seizure of a poetic moment or a revealing perspective or the revelation of visual analogies. Commercial photography used these very strategies to the promotion, like commercial art, of products, and so it bore the stigma of merchandizing and hence of rhetoric, against both of which there are ancient philosophical prejudices. Indeed, rhetoric penetrated the way in which photography presented information, as in photojournalism – though it was rarely asked how the prejudice against rhetoric was to be reconciled with the attitude that the camera was a mere machine for the reproduction of the visual world. In any case, there developed a kind of class-structure among photography images, with an aristocracy of proto-paintings allowed into the precincts of high art, and a proletariat of working photographs playing productive roles in the facilitation of life: celebrating, enhancing, informing, memorializing, exciting, recording, documenting, teaching, identifying, and in general interacting with the persons who lived a form of life in which the working photograph had an integral place. It is a further contribution of the Pop revolution that these images, once brought to artistic self-consciousness, were perceived as vehicles of meaning and attitude and belief which high-art photography could not hope to capture – a richness which Warhol was especially ingenious in exploiting, using the format of the newspaper (or the police) disaster shot, the bland and unforgiving poster shot of most-wanted criminals, the absolutely mechanical repetition of the four-shots-for-a-dollar images from the photomaton, the instant dumb registrations of the household polaroid. Actual photographs were appropriated, re-photographed, and enlarged to compose works of an almost unendurable poignancy, as in the great tragic statements of Christian Boltanski. More than this, many of the attributes of the working image – the graininess, the awkwardness, the stiff poses plain men and women take

before the camera, the innocent uncomposedness of the ordinary snapshot, the inadvertent cropping, the accidentalities of false focus and overexposure and reflections on the camera lens which compromise its metaphysical transparency – suddenly became part of high-art photography, which turned its back on its own aesthetic imperatives in its pursuit of immediate meanings. In some sense, one feels, a great democratization of images was achieved in this period, where any image at all was felt to possess some social and hence artistic significance. And though there continues to be a photographic art that carries forward the aristocratic format of controlled illumination, sharp contrasts, studio conventions, and revealing juxtapositions, as in the work of Robert Mapplethorpe, there is no longer a sensed imperative that this is the way photography must be. The swanky mapplethorpian image – elegant, arrogant, crystal-clear – cannot really be detached from a camp sensibility that referred, self-consciously, to the movie habitats of Fred Astaire and Ginger Rogers: the Manhattan penthouse, the stateroom of the ocean-liner, the polished chrome and satin of nightclubs in Rio, Havana, and Hollywood. In its own way, it too is appropriation, taking for its own expressive purposes working images used decades ago by portrait photographers and interior decorators.

The work of Cindy Sherman, pre-eminently in the stills that constitute a significant portion of it, was made possible by this deep, one might reasonably say political, transformation in the artworld, and it is with reference to this that one must work out answers to some of the questions that have been raised about her as an artist. Thus, while it is perfectly clear that her works are photographs, so much so that prints of hers routinely turn up in almost any survey of contemporary photographic expression, the question has often been raised as to whether she is a photographer. I remember being asked this question by someone anxious to have and genuinely pleased to receive a qualified negative answer. She herself says that she uses the camera as a means, the way other artists use paint and brushes, the implication being that she is interested in the image that results from procedures in which she takes a secondary interest at best. So the quality of a print is not something that concerns her except expressively, as if she would be glad if the print was on cheap paper and even blurred, in order to underscore the fact that her artistic concerns lie elsewhere. So she is not a photographer in the sense in which someone is who thematizes apparatus and chemistry, the intricacies of focus and exposure time and lens opening and shutterspeed. Her product is not the photograph as a work of art, but the work of art that happens to be a photograph. One of the revolutionary achievements of the art of the Sixties and the Seventies involved the removal of the artist from the physical realization of the work. As in so much else, Warhol pioneered in this, leaving it to assistants and hangers on to bring his works into being, using any mechanical means that might be needed. The hand of Donald Judd plays no role whatever in the fabrication of his works. Cindy Sherman is not required to trip the shutter or develop the plates, inessential to her way of being an artist.

On the other hand, like so many artists for whom photographic images were their artistic products, she was able to advance her artistic ends through a certain crucial phase of her career by seizing upon a genre of working photograph which is particularly rich in social associations, and making it her own. This is the *still*. The still is one of the chief ways in which movies present themselves to potential ticket-buyers, and as pictorial inducements are steeped in the strategies of provocation. The still's function could not be served, for example, by a frame cut from a film strip and enlarged, nor from a photograph that happens to document the actors in their setting, unless these should as a matter of coincidence conform to the requirements of the still, which is to arouse enough prurient curiosity in the passerby to justify spending money and time in seeing the film to which the still points. The still is

analogous to the lurid jacket on the paperback novel, which must compete with the other paperback novels on display for the reader's attention, money, and time. Or like any advertising image calculated to arouse a desire for the product the viewer is caused to believe must be like its image. The still, like these, is seductive, enticing, and meretricious, and the taker of stills must therefore be an astute psychologist of the narrative appetite, a visual Sheherazade. The still must tease with the promise of a story the viewer of it itches to be told. As a visual tease, the still is especially important for the B-movie with its cast of minor actors. The still for the star vehicle is an altogether different matter, since the vehicle itself answers to a different order of appetite, namely just to be in the presence of the star, whatever flimsy narrative may be used in order to make this possible, for the story in such cases is only an occasion for communion with the star. So the still need only show the star's familiar image. In fact it would suffice just to have the star's name outside the theater. Narrative photography goes back to Victorian times, back to the posed melodramas of Henry Peach Robinson, who undertook to demonstrate that the photographer could rival the painter in depicting dramatic moments in sentimental stories. But the still is a mass-culture artifact, part of the common cultural experience of movie theaters everywhere, with a showcase on one side of the ticket booth showing two or three stills under "Now Playing," while another, on the opposite side, shows a still under "Coming Attractions." And as such, the still naturally recommends itself to artists who use photography to extra-photographic artistic ends, in the same way as does the dot-screened news-service photograph or the passport photograph.

When De Kooning came to America, he was struck by a pose spontaneously taken by the girls he met at parties: they would draw one stockinged leg under them and sit on it, letting the other leg dangle. This must have been a pose thought especially sexy by cheese-cake photographers, which then became standard among actresses, and then standard in life, as much a part of Everygirl's body language as the lifted leg when The Girl was kissed. The flexed and sat-upon leg found its way into De Kooning's painting of women, who had accordingly to be American, as the lifted leg found its way into the ritual of the goodnight kiss at front doors in American cities and hamlets before the sexual revolution, or the slangy way men and women talked to one another in movies became standard discourse in everyday communication between the sexes. It is widely appreciated that the movies penetrate our consciousness of ourselves and define the narratives in terms of which we see our lives. So the still is a natural way to represent ourselves. In any case, as we shall see, there is a powerful identification between the viewer and the subject of the still, as if the movie were about ourselves. But this brings us to the other dimension of Sherman's art.

The artistic appropriation of the 8 x 10 black-and-white still, with its corresponding activation of all the powerful feelings and connotations connected with it in contemporary pictorial culture, would all by itself have been a considerable artistic achievement. It is not difficult to imagine a photographer setting things up with props and models to produce images that will be read as stills for unmade detective movies, or (for the audience that is interested in the work of Frederick Remington or Charles Russell, but also wants to be avant-garde) as stills for cowboy movies. Indeed it is not difficult to imagine painters appropriating poses and expressions actors show in stills in order to give a certain postmodern gloss to work that wills to be histrionic or even hammy. But all this carries us only a certain distance in the understanding and appreciation of Sherman's images. In a sense, the still only provided a framework through which her deeper artistic impulses found expression.

It is widely accepted that all the stills (and nearly all her work to date after the series of stills came to an end) are *of* Cindy Sherman herself. The "of"

requires as much by way of explanation as the "by" in describing them as "by" Cindy Sherman, when the latter does not entail that she took the picture. She, Cindy Sherman, is, for example, in no sense the subject of these works, even if it is an important fact about them that they are more or less all of her. She is no more their subject than the model for a painting is the subject of the painting, even if it is true that the painting is of that model. Usually, the model stands for something other than herself, and *this* is the subject of the painting rather than the model as such. It is well-known, for example, that Delacroix posed for one of the figures in Géricault's *Raft of the Medusa.* But that painting is in no sense *of* Delacroix. It is of a haggard group of shipwrecked persons, in whose company Delacroix himself has no natural location (if he did, it would be "Delacroix with the Survivors of the Medusa," a painting like "Patron with Virgin and Saints.") Reynolds' portrait of Mrs. Siddons as the Tragic Muse really is a painting of Mrs. Siddons: it is not like a painting of the Tragic Muse, for which Reynolds happened to use Mrs. Siddons as model, for in that case she would have had her identity submerged in that of the individual for which she posed, the Tragic Muse herself. And this distinction closely corresponds to the difference between a still for a star vehicle, and a still for a B movie. A still of Garbo in *Catherine the Great* is a picture of Garbo *as* Catherine the Great. But if Garbo were the unknown lead in a B movie about Catherine the Great, a still would show Catherine the Great, for whom some unknown actress played the part. In this sense, none of Cindy Sherman's images is of Cindy Sherman *as.* They are of The Girl, for whom Cindy Sherman posed. So the images are of Cindy Sherman in a way that is incidental and even secondary in any given work, but curiously central and essential to the work taken as a whole. The whole for once is greater than the sum of its integral parts.

In whatever sense it is that the individual stills are of her, none of the works so far as I can tell is in any sense a self-portrait of Cindy Sherman. They are portraits at best of an identity she shares with every woman who conceives the narrative of her life in the idiom of the cheap movie. It is in part for this reason that her work has had a special interest for feminists who subscribe to the view that women do not hold theories but tell stories, whose way of representing the world is essentially narrativistic. And while I am uncertain that the idea of the stills of herself would have occurred to her had she not spent a fair amount of her life before mirrors in the standard way of women making themselves up and trying for this look or that, the stills do not compose a sequential exploration of her own features, nor do they stand as a monument to feminine vanity. They do not have, for example, the sequence of self-portraits by Rembrandt as an art historical precedent. Rembrandt's representations of his own features trace the inscriptions that life makes on the single human face across time, but Sherman's face is a neutral base on which she inscribes the countless faces of The Girl in her myriad embodiments. Nor do they have as contemporary counterparts the photographic studies of his own aging body by John Coplans. From Coplans's photographs of his body it would, I think, be possible to recognize his body if one saw it naked, so remarkably unanonymous are they. But I cannot imagine anyone who could recognize Sherman from the stills. Though I had studied and indeed written about them, so little does she resemble her images that I was surprised to see what she looked like when we met at last. The psychologist, Richard Herrnstein, has demonstrated, through a brilliant suite of experiments, the remarkable pictorial competence of pigeons, who are able to class photographs as of the same thing as well or, in some cases, better than human beings can do. Among the feats of which a pigeon is capable is sorting out from a set of pictures of persons those and only those that are of a single individual person, despite variations of context and costume from slide to slide. I have often wondered if one of Herrnstein's experimental subjects would

be able to recognize all of Sherman's stills as of the same person. But it is, I think, beyond the categorizing capacity of human beings, and were it not independently known that all the stills are of her, nothing perceptual would inform us that they were. It is as though her own features were submerged beneath a thousand facial appearances, as if to make the metaphysical point that every woman is The Girl, always the same however different. In this sense she is like an astonishing actress, like the actress Berma, for example, in Proust's novel, who always slips out from under in such a way that she cannot be remembered as Berma, but only as Phaedra or Andromache or whoever she played. "I listened to her," the Narrator in *Swann's Way* writes, "as though I were reading *Phèdre* or as though Phaedra herself had at that moment uttered the words that I was hearing, without its appearing that Berma's talent had added anything at all to them." Sherman has achieved the visual artist's equivalent to that order of transcendent performance by vacating the space between the viewer and The Girl, locking them together in an encompassing illusion.

Sherman's art belongs at the cross-point between the artistic appropriation of the working photograph as one line, and the use by performance artists, especially women, of the photograph as a document of a performance, as the other. In the stills, the use of photography is more integral to the performance than a photographic record of what took place, and it is important to work this out in order to get a deep and true understanding of why they are so powerful. Their uniqueness is due to their being simultaneously and inseparably photographs and performances. I think it striking that performance art and the artistic use of subartistic photographs should have arisen at the same moment in history. Eleanor Antin integrated picture postcards into one of her most celebrated performances, a main part of which was the relationship between the sender and recipient of the postcards as one form of the kind of bond between artist and audience the performance artist seeks. But Sherman has done something more remarkable. Performance art has raised some difficult questions for the classification of the arts, since it seems to involve something like what takes place on the stage, and yet seems closer to the impulses of painting, and is the sort of thing students in art-schools decide they want to do instead of painting or sculpture. In my view, it belongs on the margins of art where perhaps the differences between painting and theater dissolve, and both may be seen as evolutions out of something very primitive and ritualistic, where art is the practice of a form of magic. It is as though the performance artist has taken on herself the role of a priestess, engaged for the health of the community with the darkest sorts of powers. For the artist-priestess, the "work" is a means toward transformative ends. There are famous theories, going back to Nietzsche, according to which Greek tragedy developed out of and stood as a defense against Dionysiac rituals, in which the hero-priest interacted with the celebrant-chorus in such a way that at, and as, the climax of the ritual, the distance between them should be orgiastically blanked out, bringing them together in a single body on a new plane of being. Theater, according to Nietzsche, was predicated on a kind of distance (call it aesthetic distance) it was the purpose of the original ritual to overcome, but the memory of hope and danger of the earlier practice remained to energize theatrical performance until it degenerated into mere entertainment. Entertainment, hence theatricality, is exactly what the performance artist of today repudiates. It is a response to the separation of artist and audience, as much a problem for painting as for theater, and her performance (the greatest performance artists are women) is atavistic, in that it is enacted in the faith that something transfigurative and even sublime will transpire, the overcoming of the boundaries between person and person. In performance, accordingly, art is to have restored to it the danger and magical power it lost when it became art, something set apart from life

and to be enjoyed as a matter of aesthetic pleasure. In fact, very few performance artists are up to this stunning ambition, and in actual practice a great deal of performance art is sheepish, selfconscious, foolish, scruffy, and awful. Nonetheless, I hold it in great respect for what it aims at. I once coined the expression "disturbatory" to describe the ideal moment of performance art. Like its obvious rhyme in English, in which fantasies climax as real spasms, disturbatory art seeks real transformations through charged artistic enactments. The performer puts herself forward as the means for inducing a redemptive climax. It requires great courage. Real risks are run.

At one stage in her evolution toward the stills, Sherman took on the mission of the performance artist by appearing at events such as openings in the gallery in which she worked as a receptionist in one or another dissonant costume – a nurse's uniform, for example. These were unscheduled and in effect unannounced performances, more or less to see what the effect would be on others and perhaps on herself, as an artist who, in transforming her appearances, set up perturbations across a social field in which she and others were initially just externally related. Sartre talks of such transformations, from what he calls a *"groupe-en-series"* to what he calls a *"groupe-en-fusion."* Sartre's paradigm of the former is a number of people waiting for a bus, each bent on his or her own business, though a gallery opening would serve as well. His example of the latter is a mob of people fused into a single social body by storming the Bastille, an event ephemeral but morally sublime in which the walls between selves dissolve. The transformation from a serial group to a fused one corresponds in a rough way to the ancient intention of the ritual, and though Sherman may not have had anything quite that exalted in mind, she had an experimental interest in seeing if the costume would have any transformative effect at all. (Sherman has expressed admiration for the performance artist and philosopher, Adrian Piper, who once entered a subway

car having rubbed herself all over with garlic.) Evidently these exploratory performances were not especially successful, largely because she was misperceived. These took place in the early 1970s, when Sherman lived in an artworld in which performance and conceptual art were matters of intense discussion, but even so she was perceived as someone merely dressing outrageously, for purposes perhaps of entertainment or shock, when her intentions were theoretical and artistic.

I do not know whether Sherman had herself photographed on one of these abortive occasions, but if she had been, the photograph would have been incidental to the process, which it would merely have documented from the outside. I have spoken of that line of performance artists whose performances were recorded in this way, giving a certain archival permanence to actions that were inherently fleeting. The bond between artist and audience intended in performance obviously does not come into a photograph of the performer in action. The camera would similarly play an external and recording role in another of Sherman's projects of that era, in which she made her face up in somewhat comical ways – like a clown, in effect – in an experiment, one feels, to see how different she could get herself to look. Perhaps, too, she was interested in seeing what the effect on herself would be if she in fact looked like that – a sort of pictorial dialogue between objective appearance and subjective feeling, with Cindy Sherman artist and audience in one. This was a cycle in which only a mirror was required to effect the experiment, but there exist photographs of her from 1975 that are funny, but not especially deep.

The camera becomes more essential in a different project, in which she sought to change herself into the girl or woman whose image appeared on one or another of the mass magazines for a female audience, and then photographed herself as if on the cover of *Vogue* or *Cosmopolitan*. With these, the photograph was the work rather than the record of the work, as in a photograph I saw from her student

days at Buffalo, where she took several pictures of herself in different costumes, cut them out and then combined them, and then took a photograph of the whole, a possibility analogous to a tape in which a singer is able by artful re-recording to sing with himself. The magazine covers with her face would be like a dollar bill in which one replaces George Washington's likeness with one's own. It was a brilliant but essentially limited idea, with the real energy of the work being carried by the connotations of the magazine covers themselves as working images. The impulse in a way had been anticipated by Duchamp, who first transformed himself into his female avatar, Rrose Sélavy, had him/herself photographed by Man Ray, then had the photograph reproduced onto the label for a perfume bottle with some modified lettering, and *then* had the label pasted onto a (real) bottle of Rigaud Parfum. Man Ray photographed the result, which appears as one of Duchamp's works as the cover for the magazine *New York Dada.* It is difficult to imagine Duchamp leaving the cover of a magazine alone, apart from substituting his own image for the one already there. He would have made some sort of verbal joke *(Vague* for *Vogue* perhaps): he did not anticipate the Pop movement's fixation on the working image of everyday life.

The camera finally becomes collusive with the stills, just because the still is antecedently photographic. Even if Sherman had herself made up and posed herself the way The Girl in the still does, the conventions of the still would have defined the look, the posture, and the mood of the pose. The camera, in brief, does not now simply document the pose: the pose itself draws on the language of the still in such a way that even if it were never photographically recorded, the pose would be the photographic equivalent of a *tableau vivant.* Since the scene and the actors who compose the still do so for the sake of the still, the camera is internal to the work. And with her breakthrough to the still, everything came together for Sherman: a oneness with her means, a oneness with her culture, a oneness with a set of

narrative structures instantly legible to everyone who lives this culture, and so a oneness with her presumed audience. The stills acquire consequently a stature as art which draws together and transcends their artistic antecedents. Sherman's genius consists in the discovery that one can attain the ends of performance art through pre-empting photographs that already connect with the consciousness of her audience. She has found image after image within the convention of the still to which I return obsessively, again and again, as to a peremptory fantasy. The still has given her a way into the common cultural mind, obliterating the distances between her self and our selves, and between self and self among us.

The still dis-stills. It does not so much give us a frozen moment of a continuous action (like a freeze frame) as it condenses an entire drama. The stills are dense with suspense and danger, and they all look as if they were directed by Hitchcock. The invariant subject is The Girl in Trouble, even if The Girl herself does not always know it. In Barbie-doll garments, in the suburbs or at the beach or in the city, The Girl is always alone, waiting, worried, watchful, but she is wary *of,* waiting *for,* worried *about,* and her very posture and expression phenomenologically imply The Other: the Stalker, the Saver, the Evil and Good who struggle for her possession. She is the Girl Detective; she is America's Sweetheart; she is the Girl We Left Behind, soft and fluttering in a world of hard menace: the Young Housewife, pretty in her apron, threatened in her kitchen; Cindy Starlet, Daddy's Brave Girl, The Whore with the Golden Heart, Somebody's Stenog, Girl Friday, with obstacles to meet, enemies to overcome, eyes to lift the scales from, hard hearts to soften, the Kid in the Chorus, love light burning in her big, big eyes, with a smile for everyone, a kind word for all, not a mean bone in her body, The Girl Next Door, Everyman's Dream of Happiness. The Girl condenses the myths that define life's expectation in Middle American fantasy, and we all know all her stories. The Girl is feminine to her fingertips, Vulnerability is

her middle name, and yet she has all the great virtues: bravery, independence, determination, spunk and a tremulous dignity. Even so, the stills are not in my view merely feminist parables. The Girl is an allegory for something deeper and darker, in the mythic unconscious of everyone, regardless of sex. For The Girl is the contemporary realization of the Fair Princess in the Far Tower, the red-clad child in the wolf-haunted woods, the witch-sought Innocent lost in trackless forest, Dorothy and Snow-White and The Littlest Rebel in a universe of scary things. Each of the stills is about the Girl in Trouble, but in the aggregate they touch the myth we each carry out of childhood, of danger, love, and security that defines the human condition where the wild things are.

I can think of no body of work at once so timeless and yet so much of its own time as Cindy Sherman's stills, no oeuvre which addresses us in our common humanity and at the same time induces the most advanced speculations on Post-Modernity, no images which say something profound about the feminine condition and yet touch us at a level beyond sexual difference. They are wry, arch, clever works, smart, sharp, and cool. But they are among the rare works of recent decades that rise to the demand on great art, that it embody the transformative metaphors for the meaning of human reality.

The stills absorbed Cindy Sherman's artistic energies for about three years, from some time in 1977 until 1980, and the sequence ran to about eighty images, so far as I can tell. The stills continued an impulse that animated Sherman from her student days, to use herself as an artistic means, transforming herself as a way of eliciting transformations in her audience, and finding some way to use photography in this performative enterprise. That impulse has continued to engage her, in larger works, now using color, and through more and more elaborate transformations of herself. She stopped making the stills when, as she puts it, she ran out of clichés. The concept of the cliché connects, of course, with that of the myths of everyday life which the still embodies, and by putting aside the format of the still, Sherman also put aside a connection with the photographic language of those commonplace images. That required great confidence in herself as an artist, for the language from which she declared her independence is sustaining and powerful. Even so, the still must at last have been a confining format for her, and perhaps she sensed in it a danger that she herself might become a cliché. The shift from black-and-white to color, from the 8 x 10 format to the large and finally to the very large format, the shift from The Girl to the Female Power, and from the kind of trouble Girls get in to the deep perplexities of death and deformity and dismemberment, which so much constitute the content of her later images, may as much mark a change in the world and a change in the demands on art as a change in her, or an internal development of her vision. But that belongs to another narrative.

PLATES

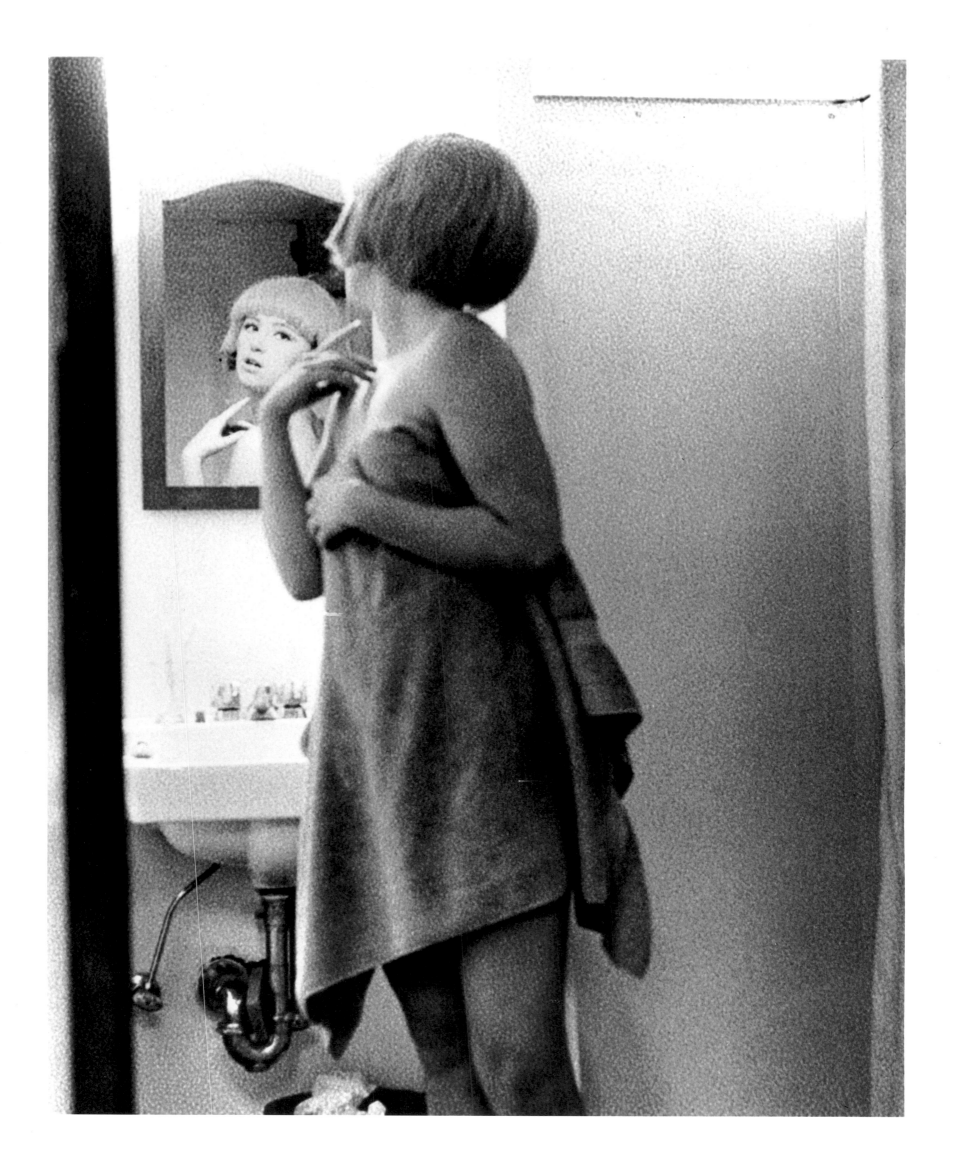

1 Untitled Film Still # 2, 1977

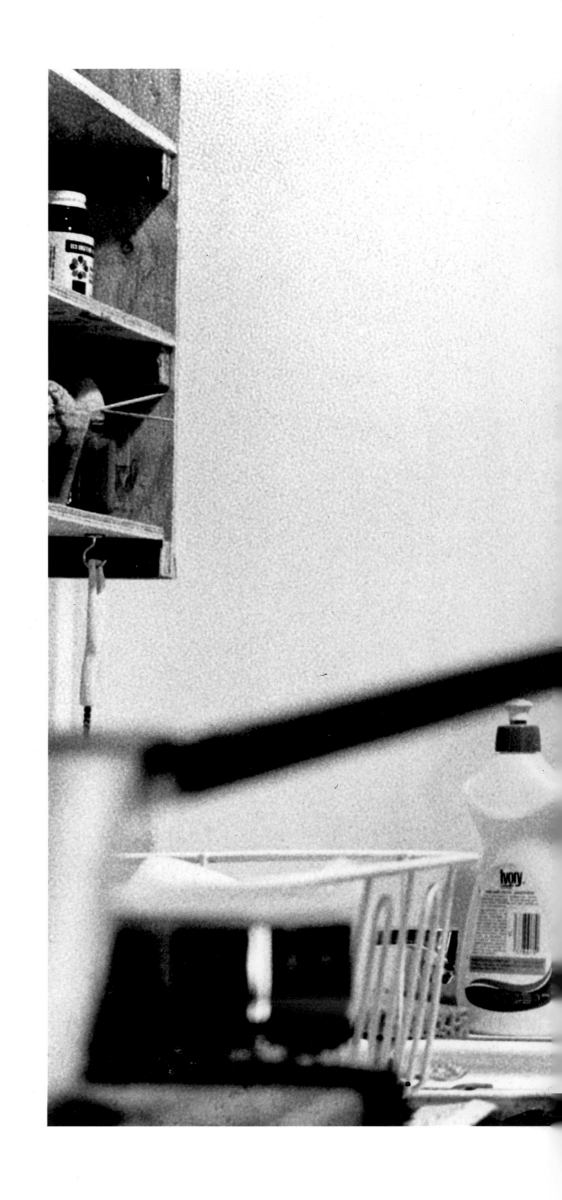

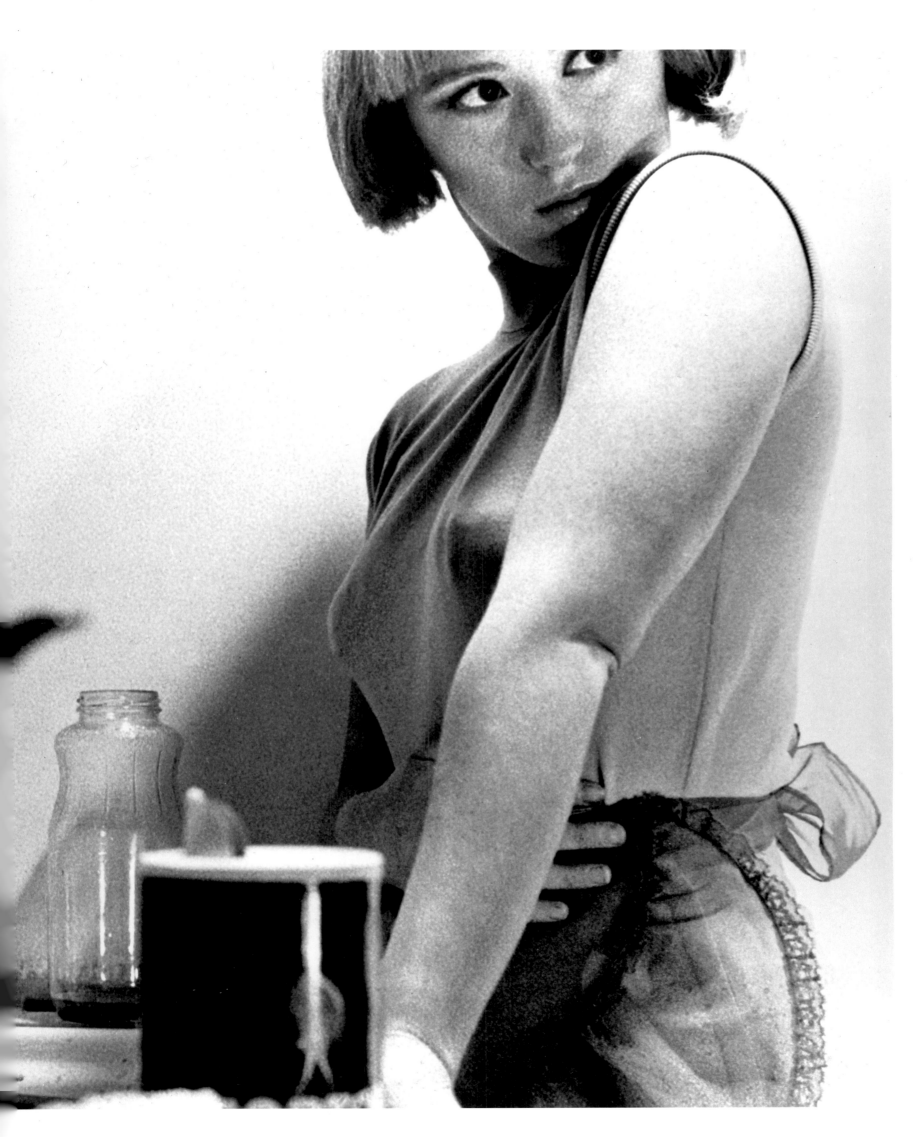

2 Untitled Film Still # 3, 1977

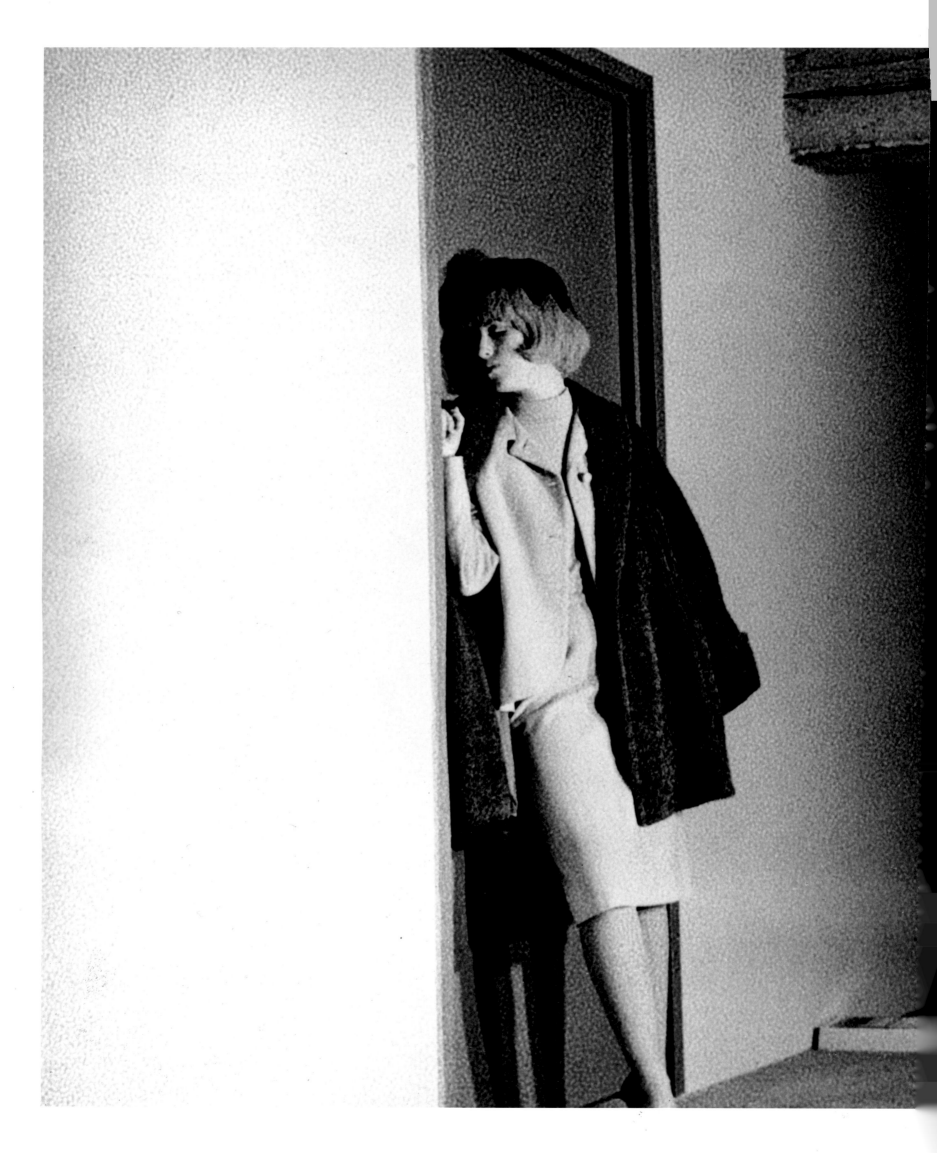

3 Untitled Film Still # 4, 1977

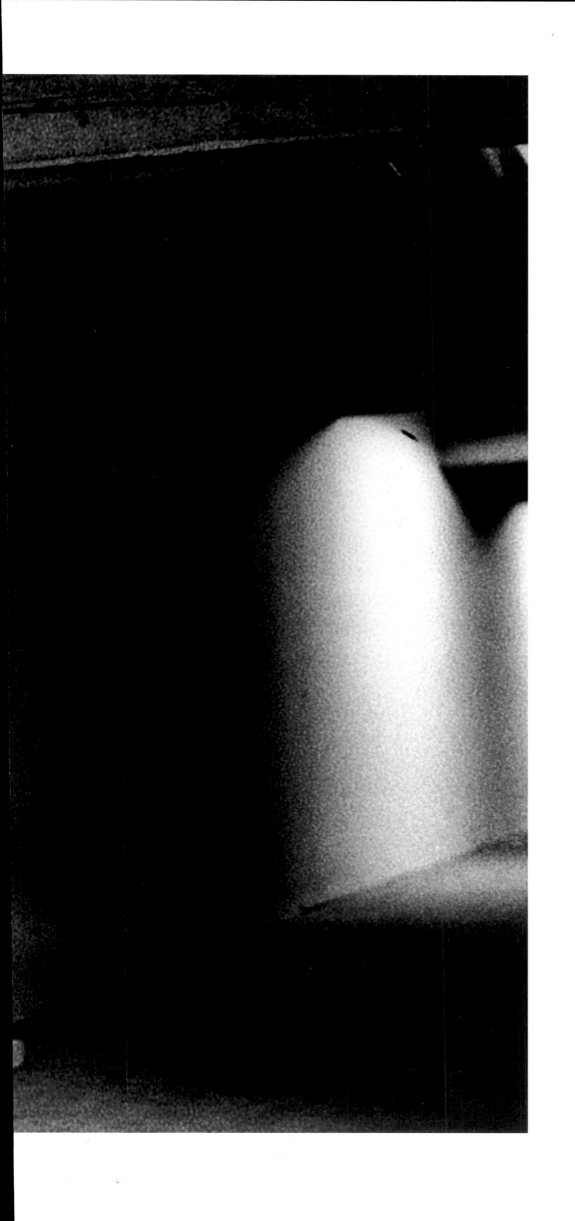

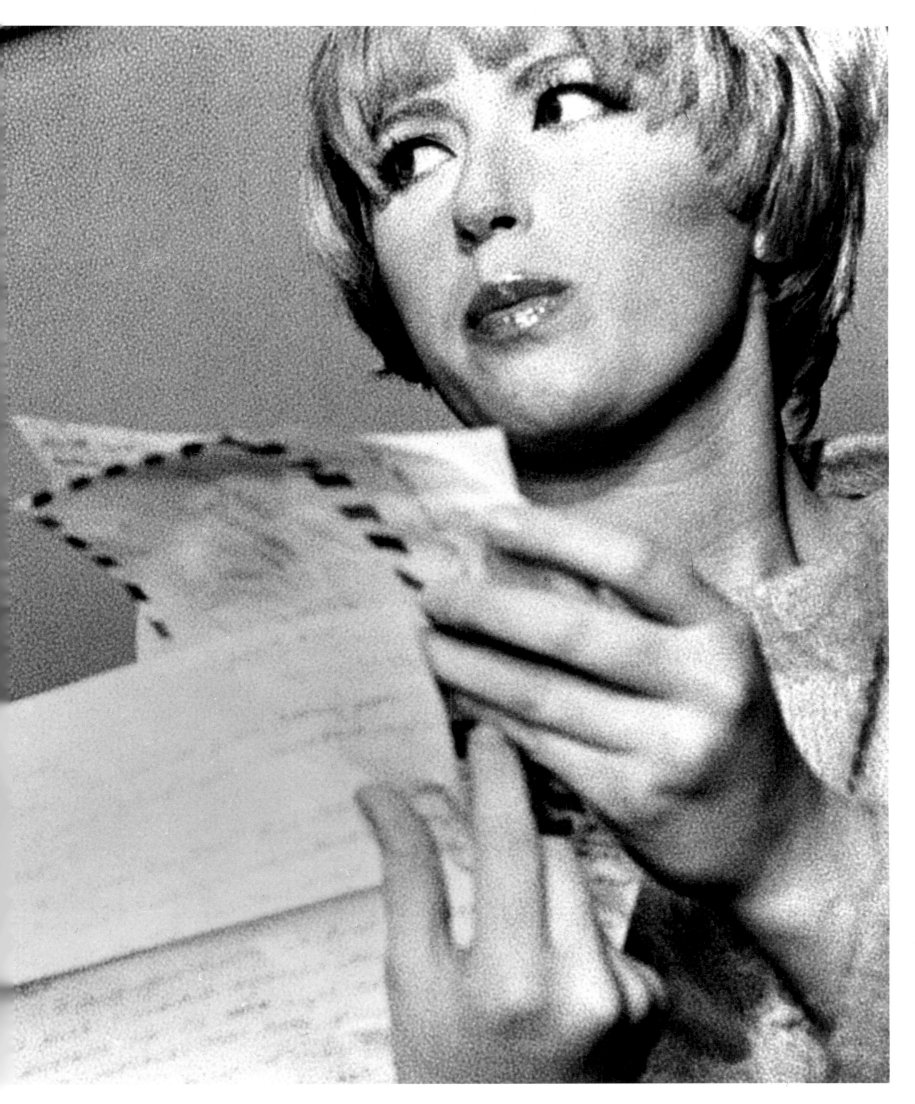

 4 Untitled Film Still # 5, 1977

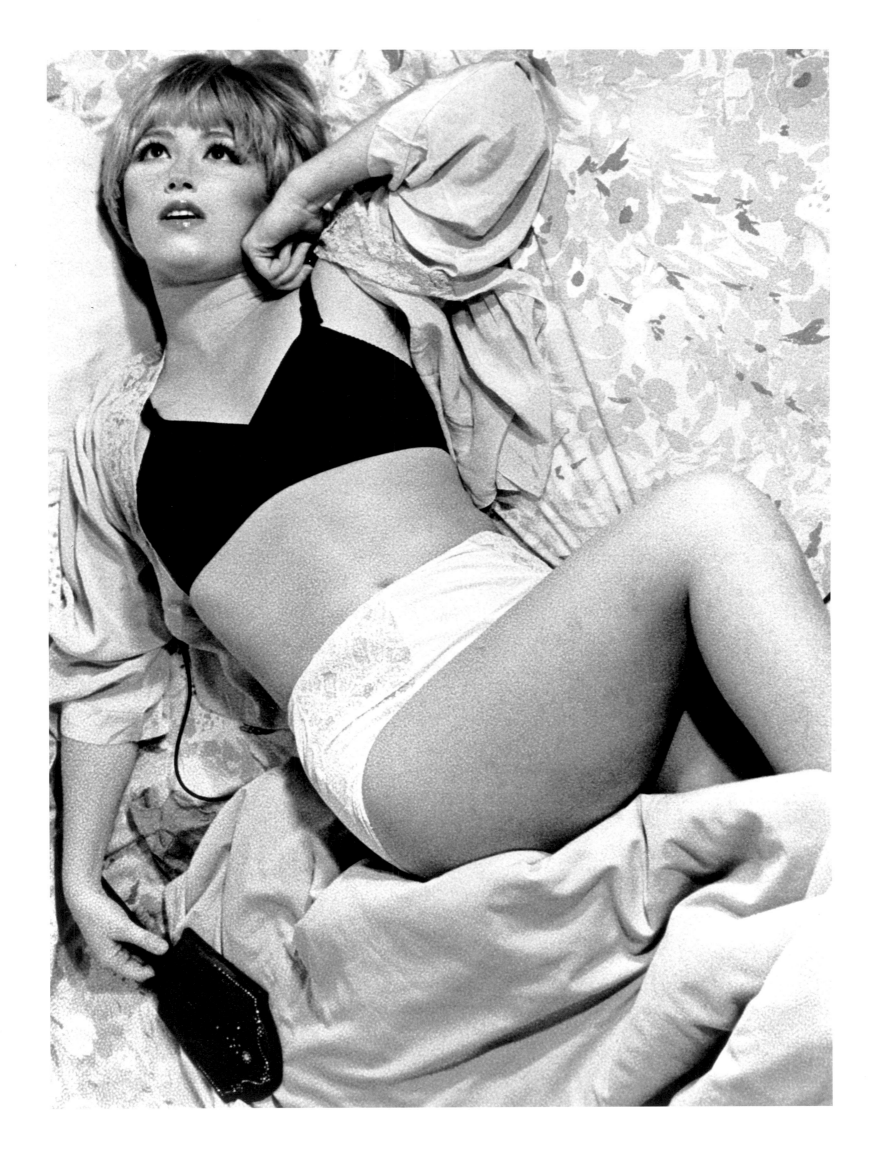

5 Untitled Film Still #6, 1977

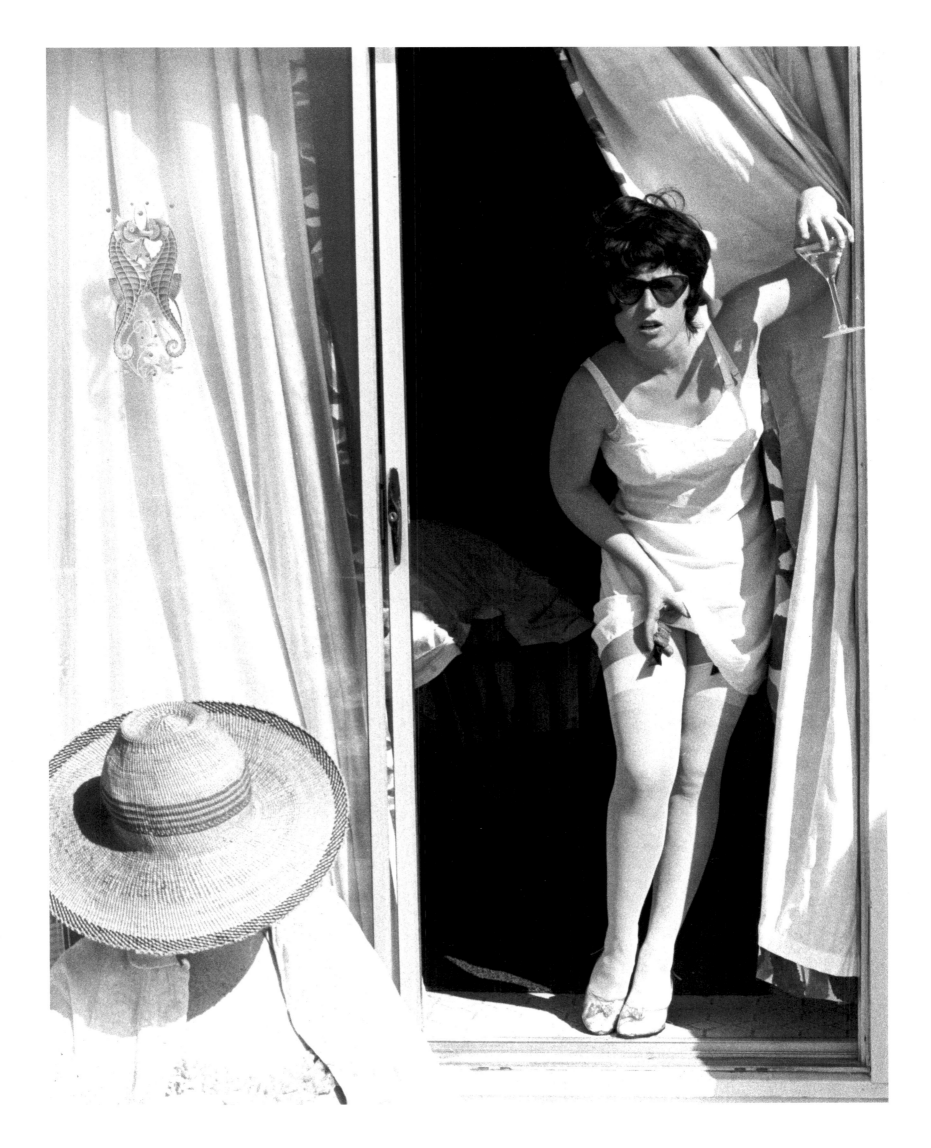

6 Untitled Film Still # 7, 1977

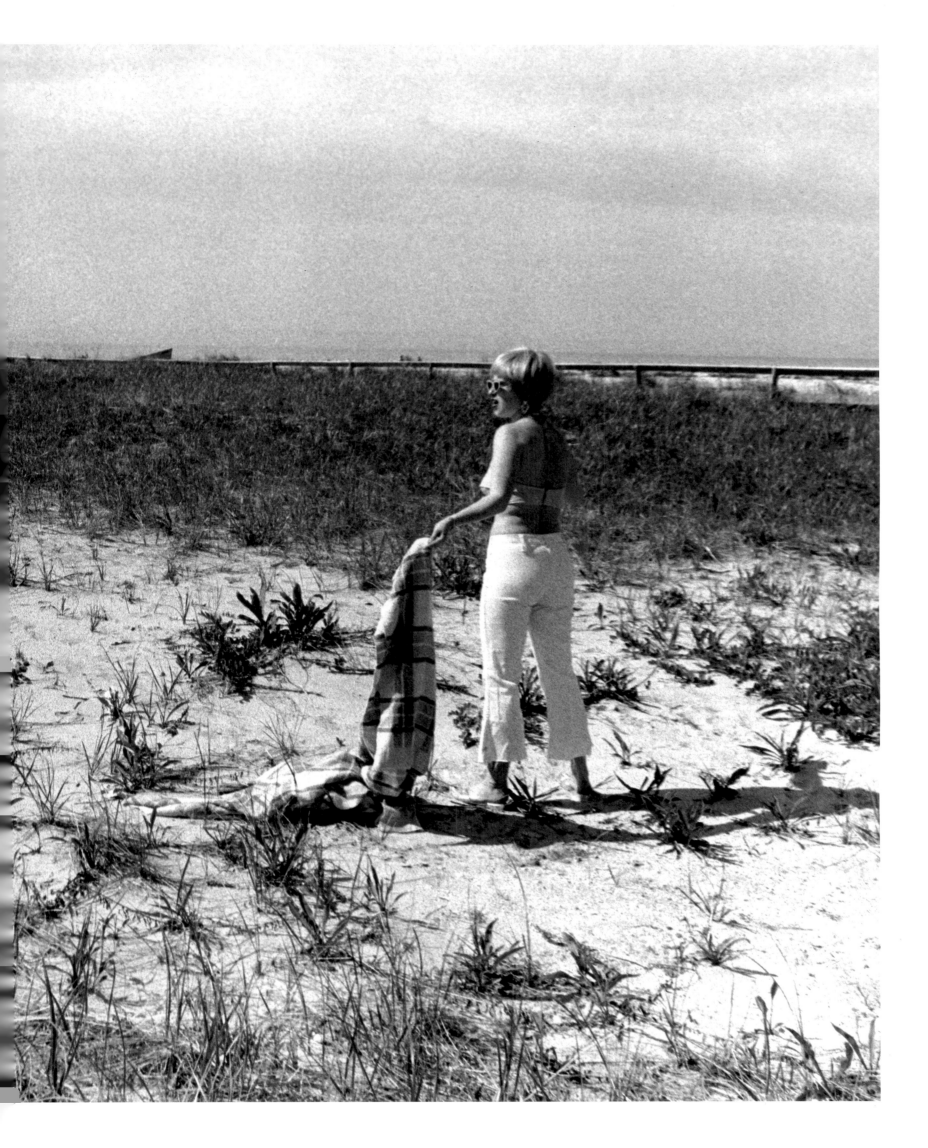

7 Untitled Film Still # 8, 1978

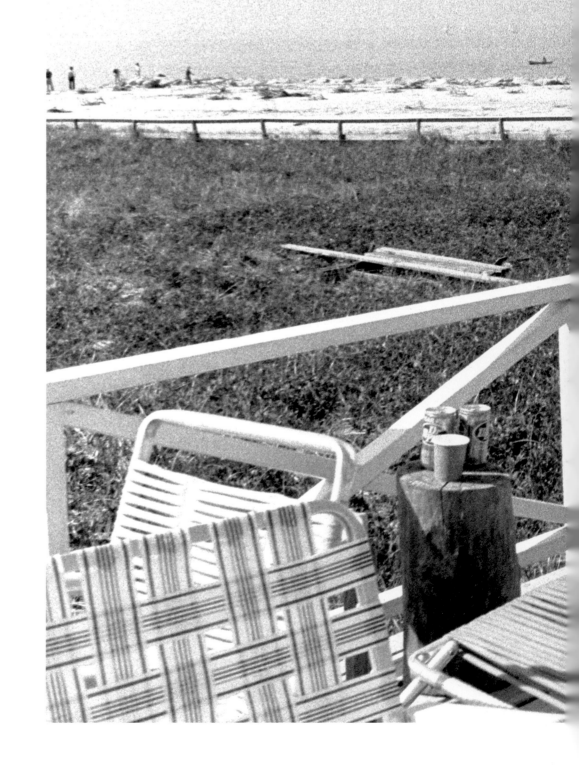

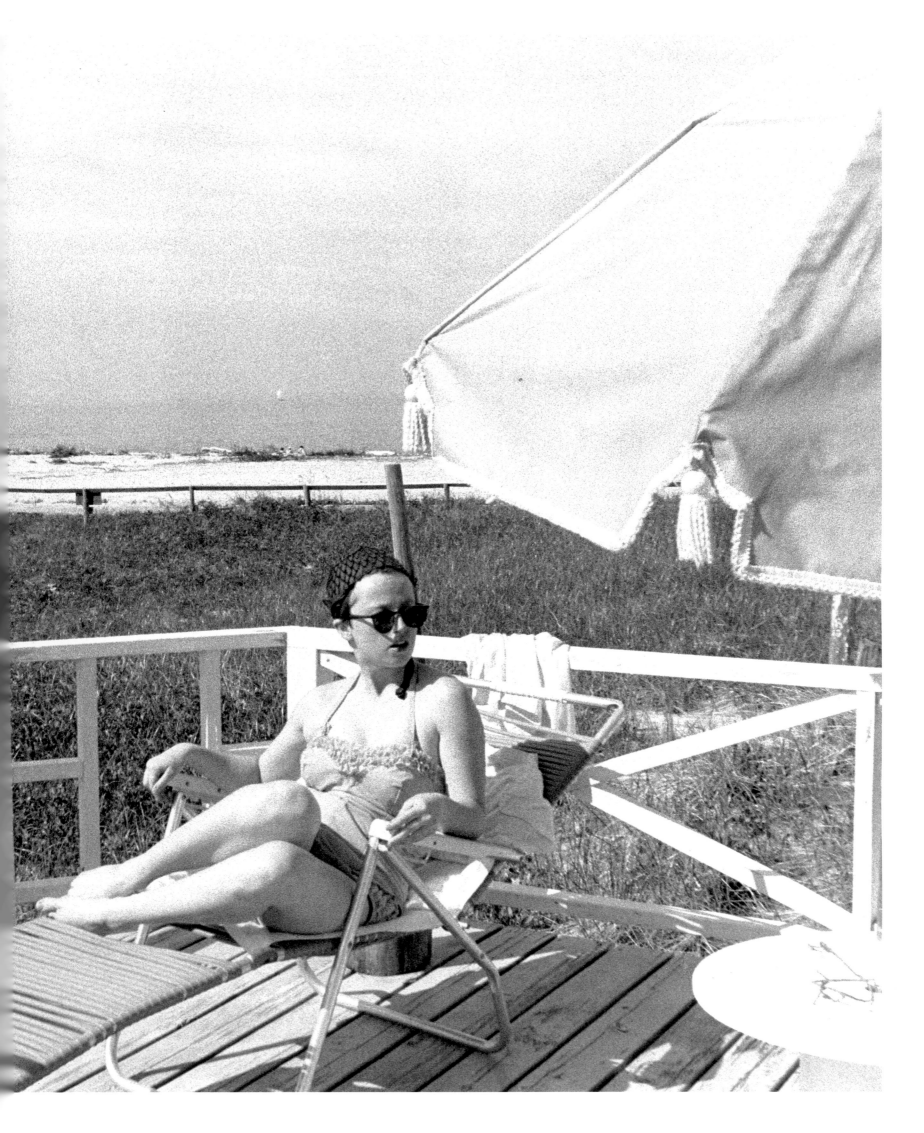

8 Untitled Film Still #9, 1978

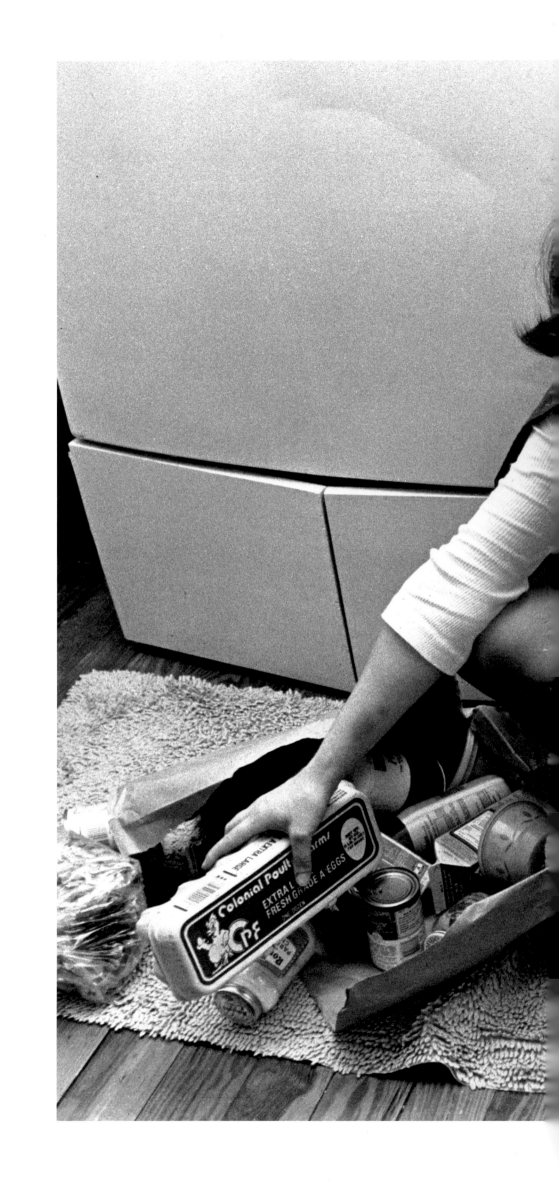

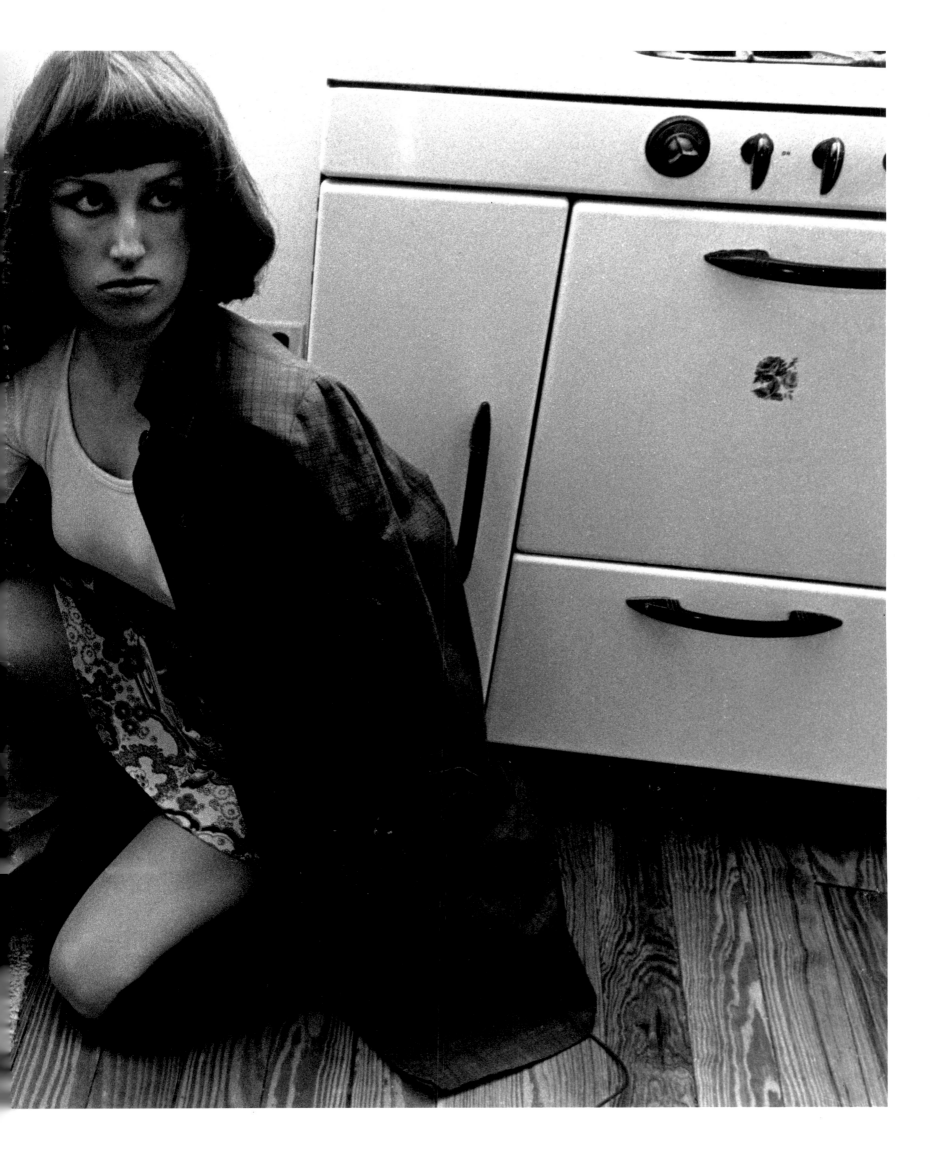

9 Untitled Film Still # 10, 1978

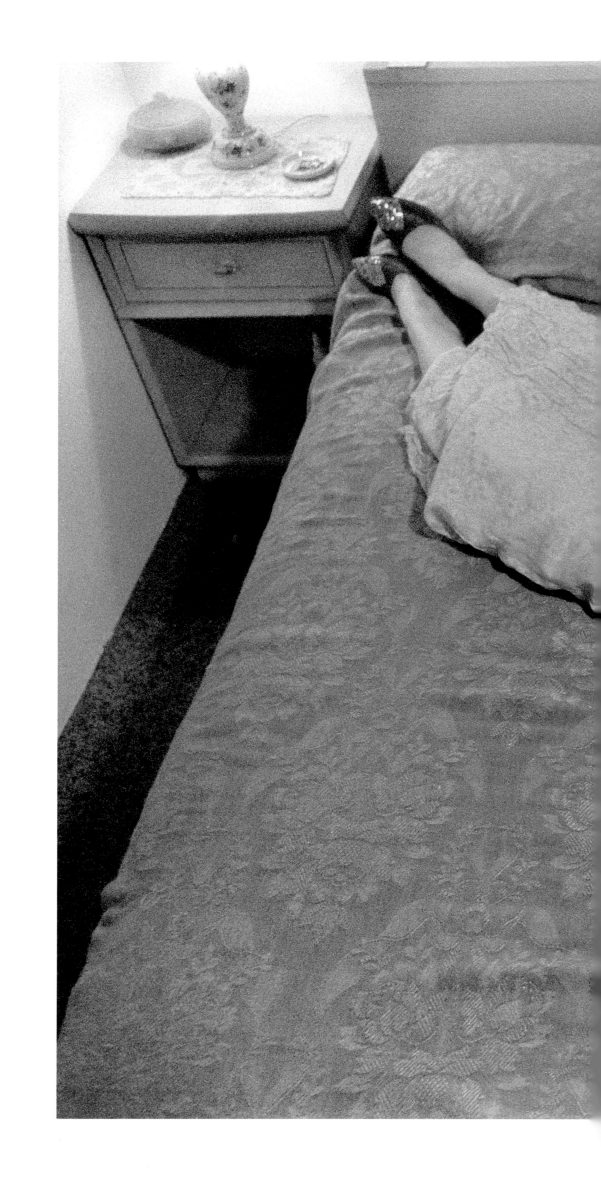

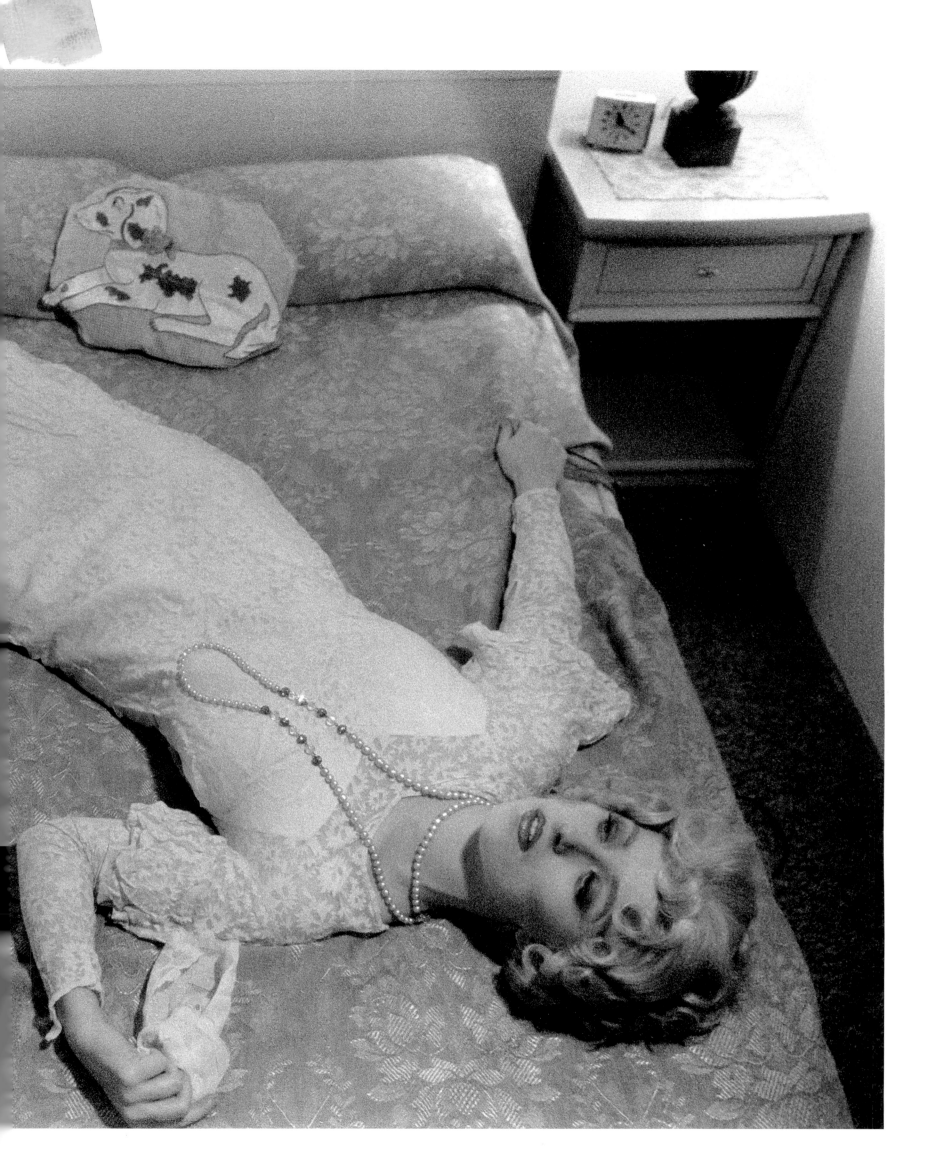

10 Untitled Film Still # 11, 1978

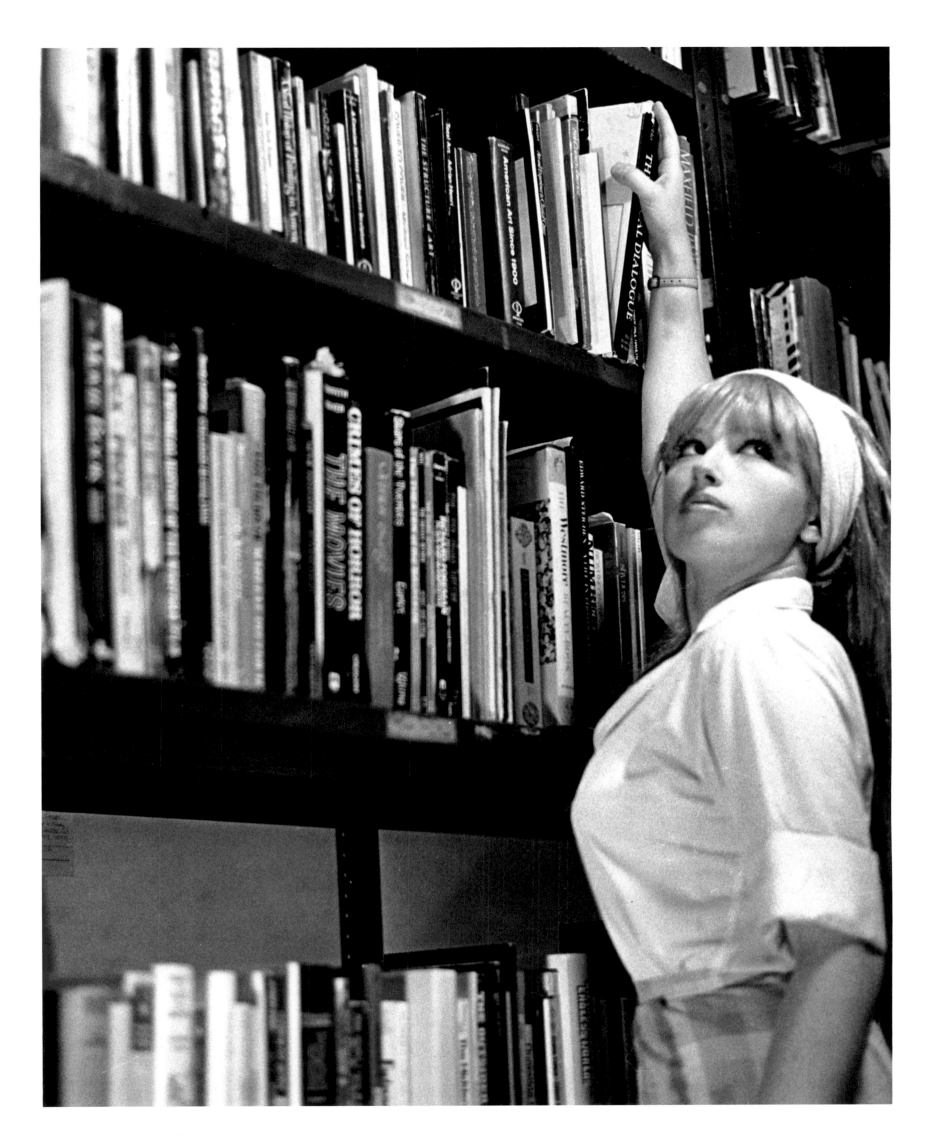

 11 Untitled Film Still # 13, 1978

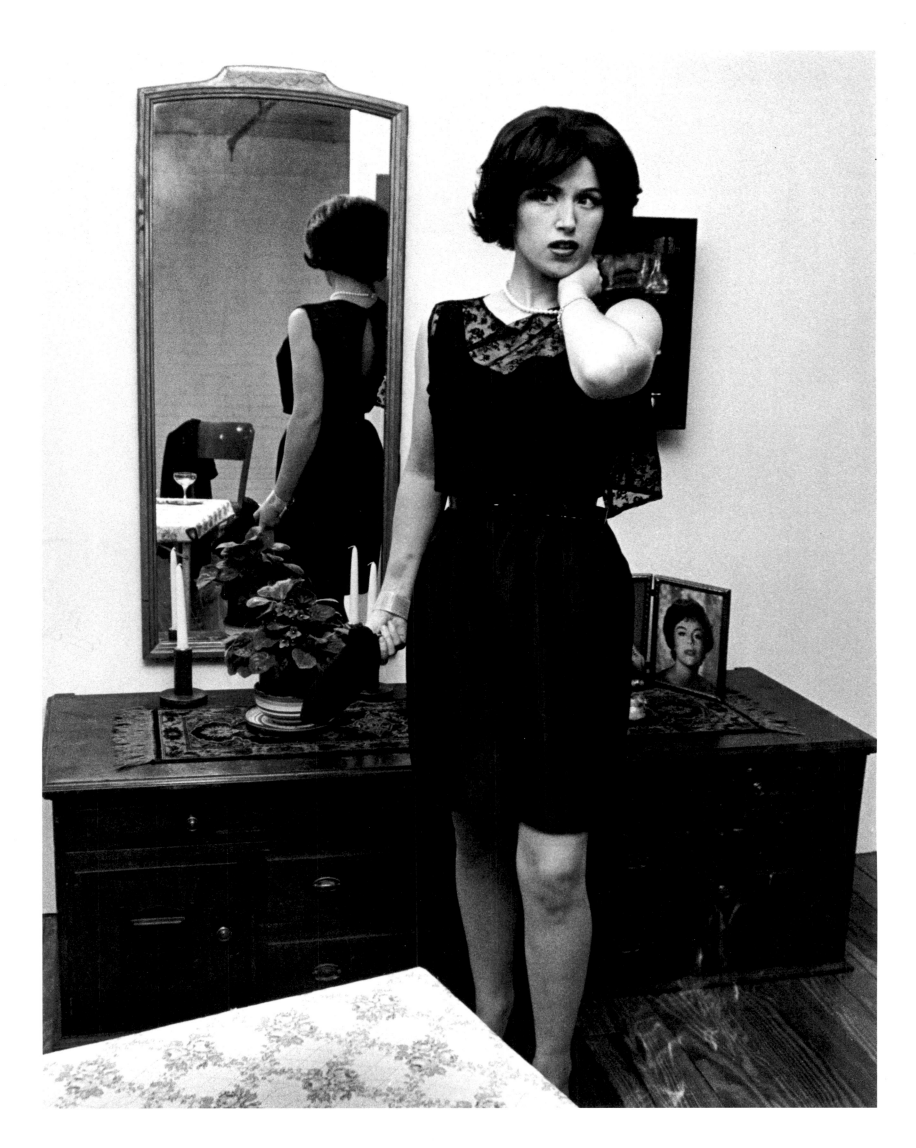

12 Untitled Film Still # 14, 1978

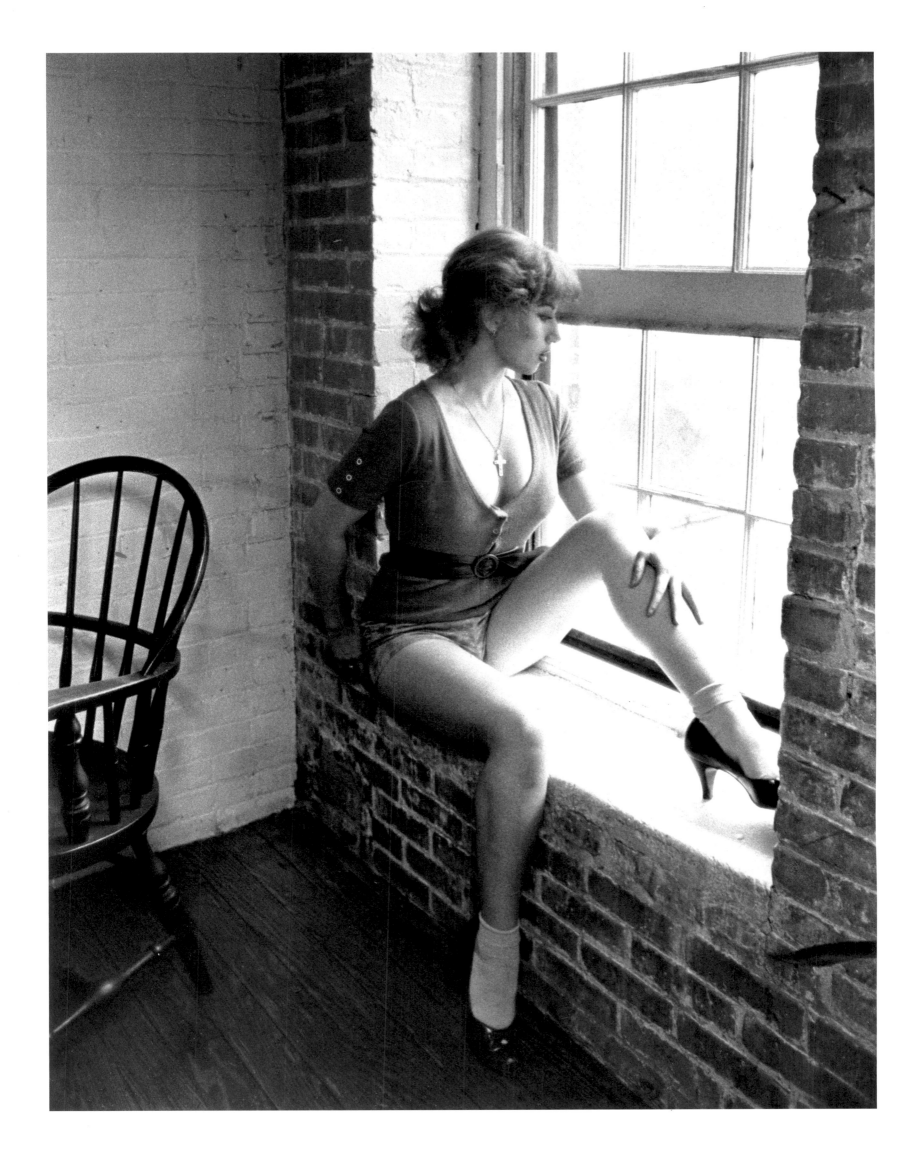

13 Untitled Film Still # 15, 1978

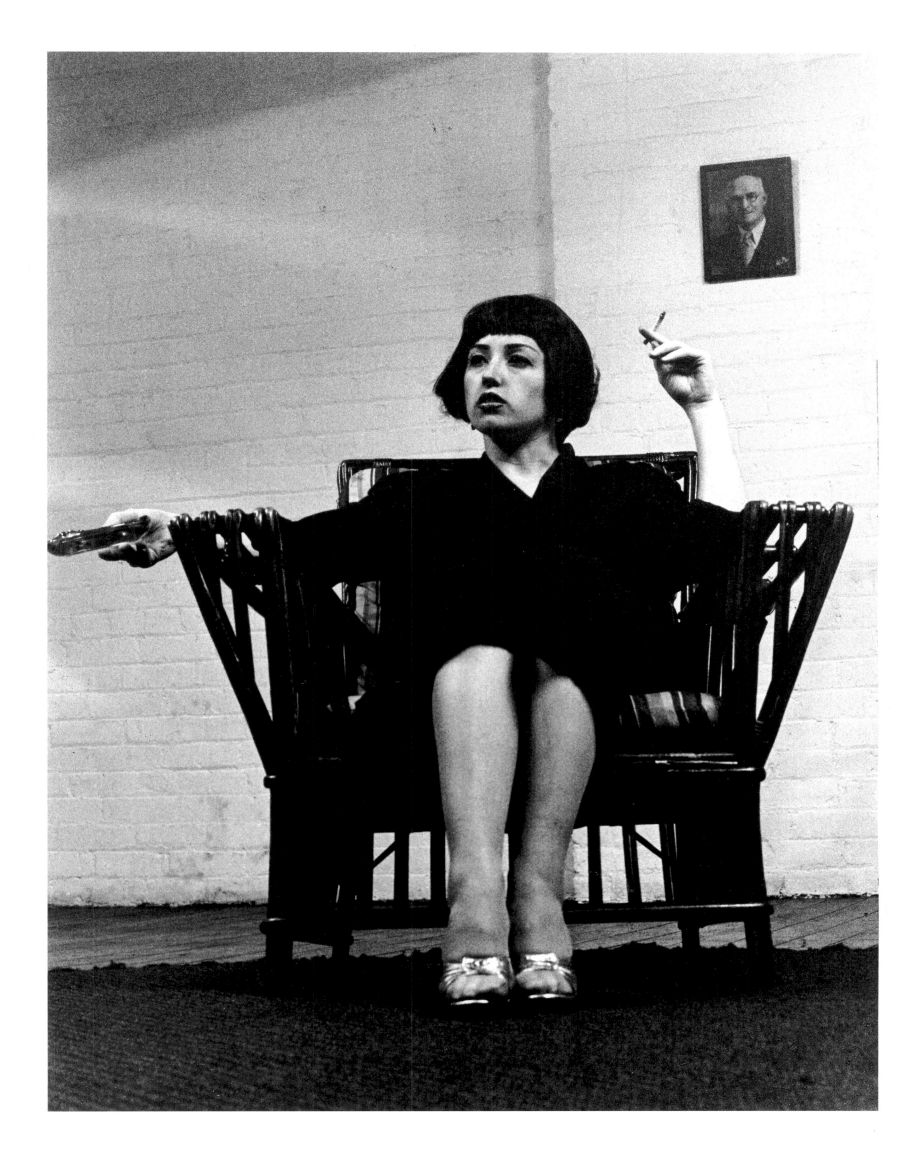

14 Untitled Film Still # 16, 1978

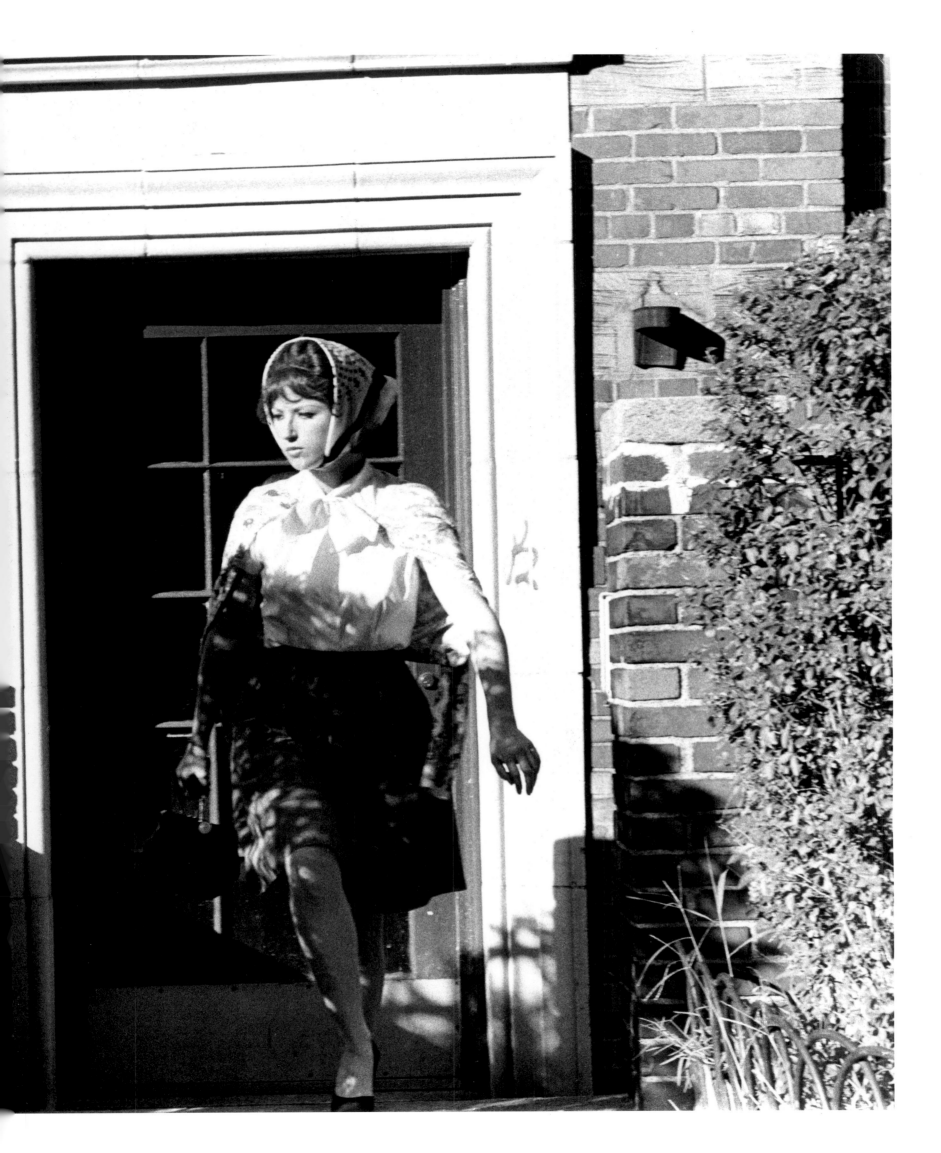

15 Untitled Film Still # 20, 1978

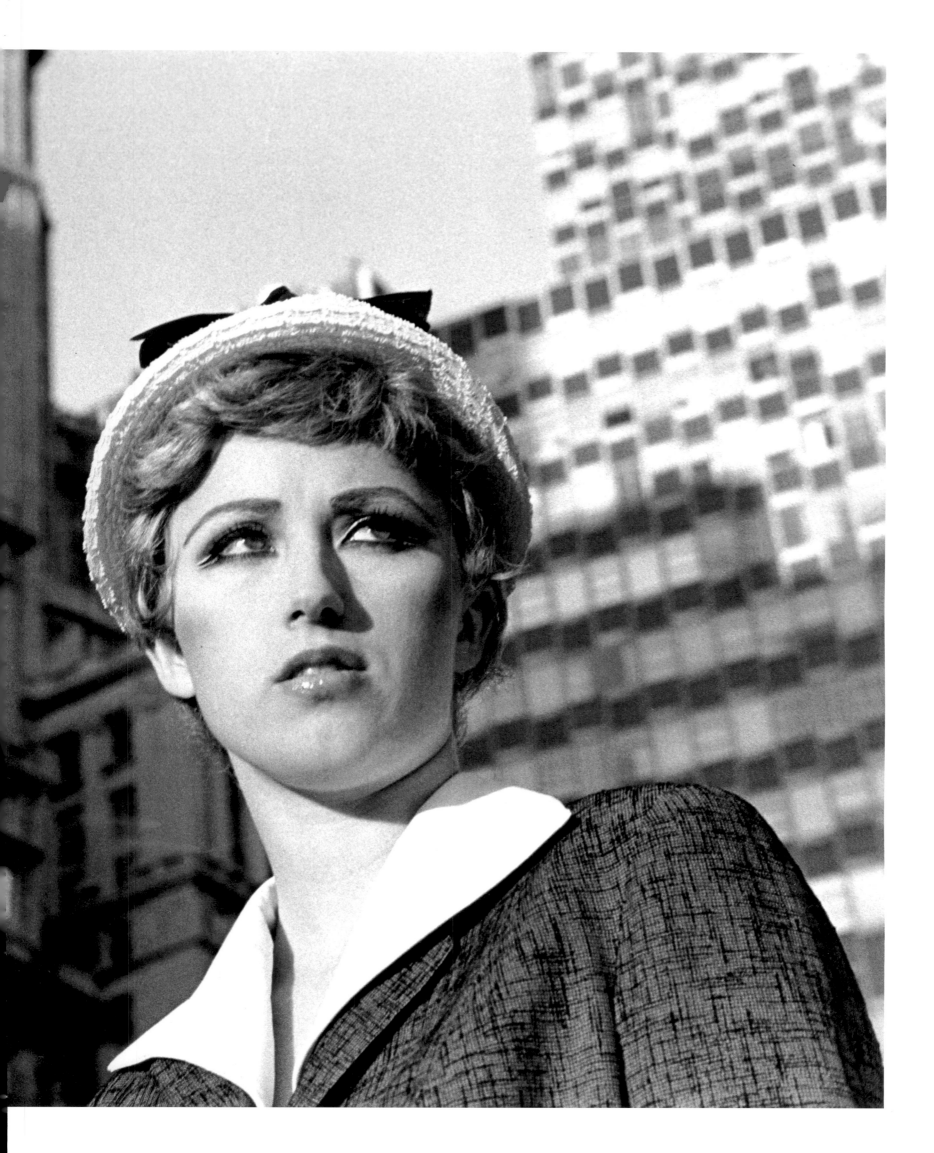

16 Untitled Film Still # 21, 1978

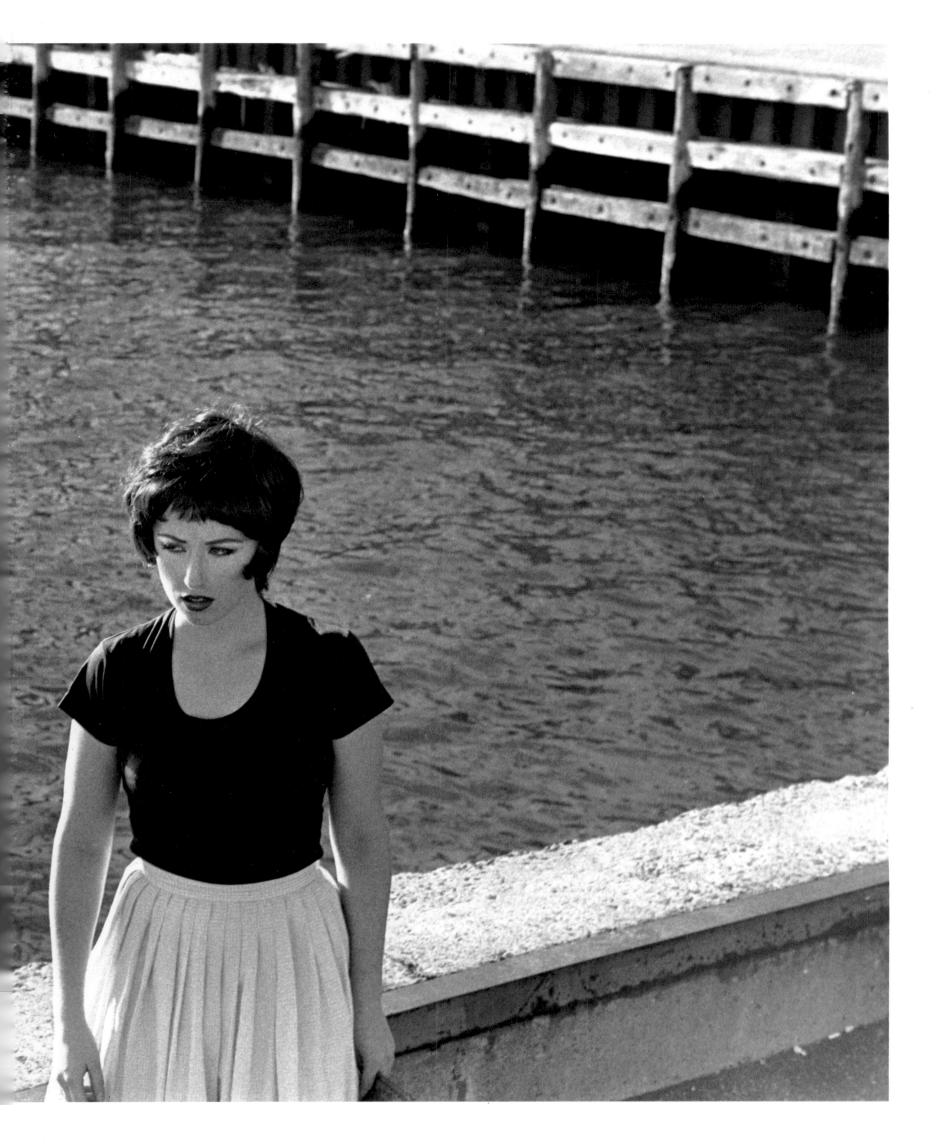

17 Untitled Film Still # 25, 1978

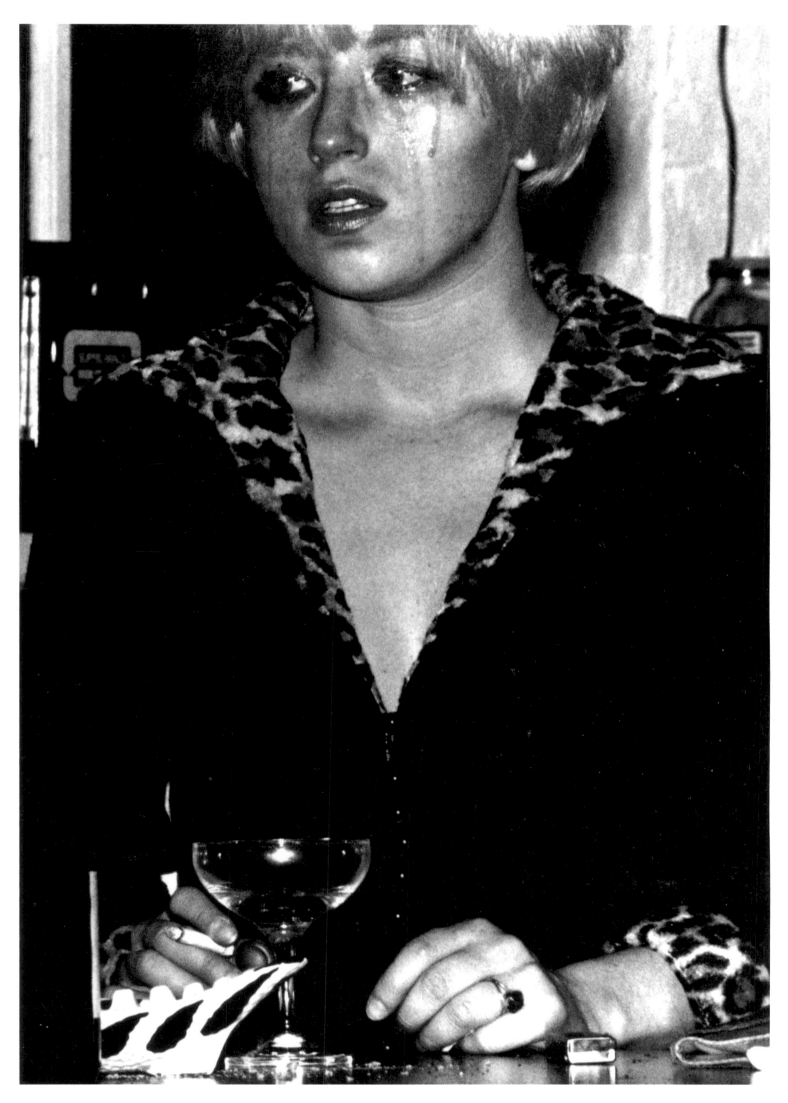

18 Untitled Film Still # 27, 1979

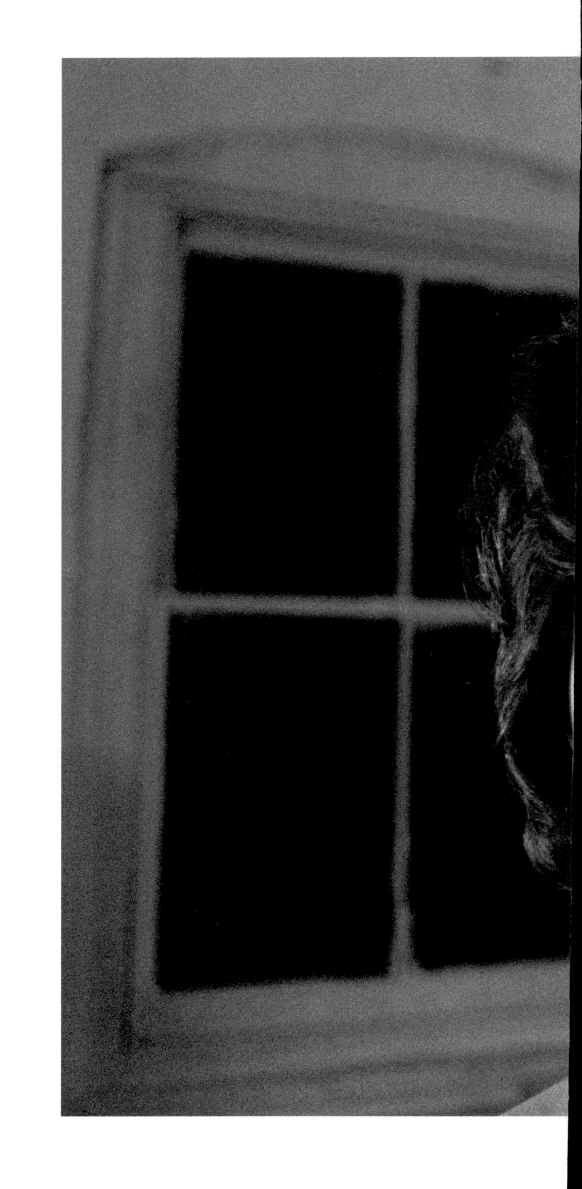

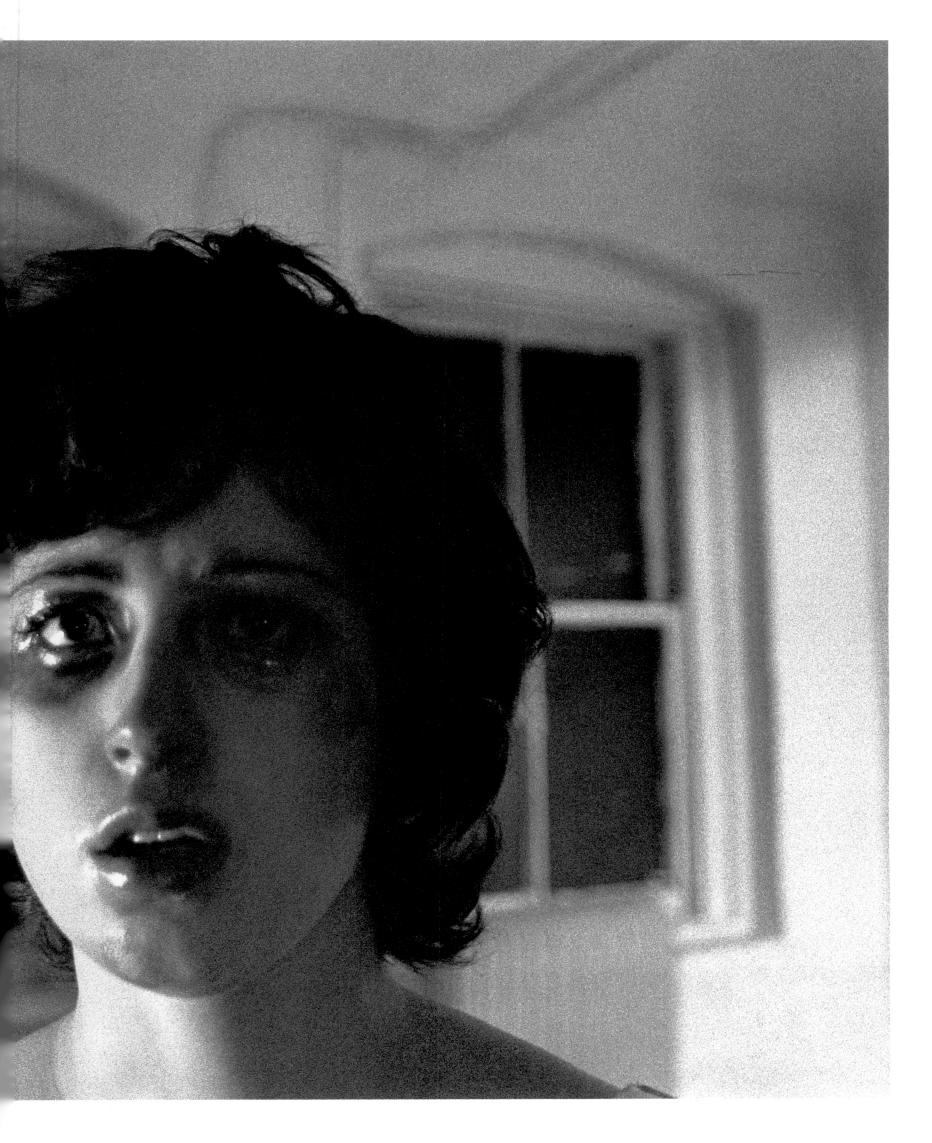

19　Untitled Film Still　# 30, 1979

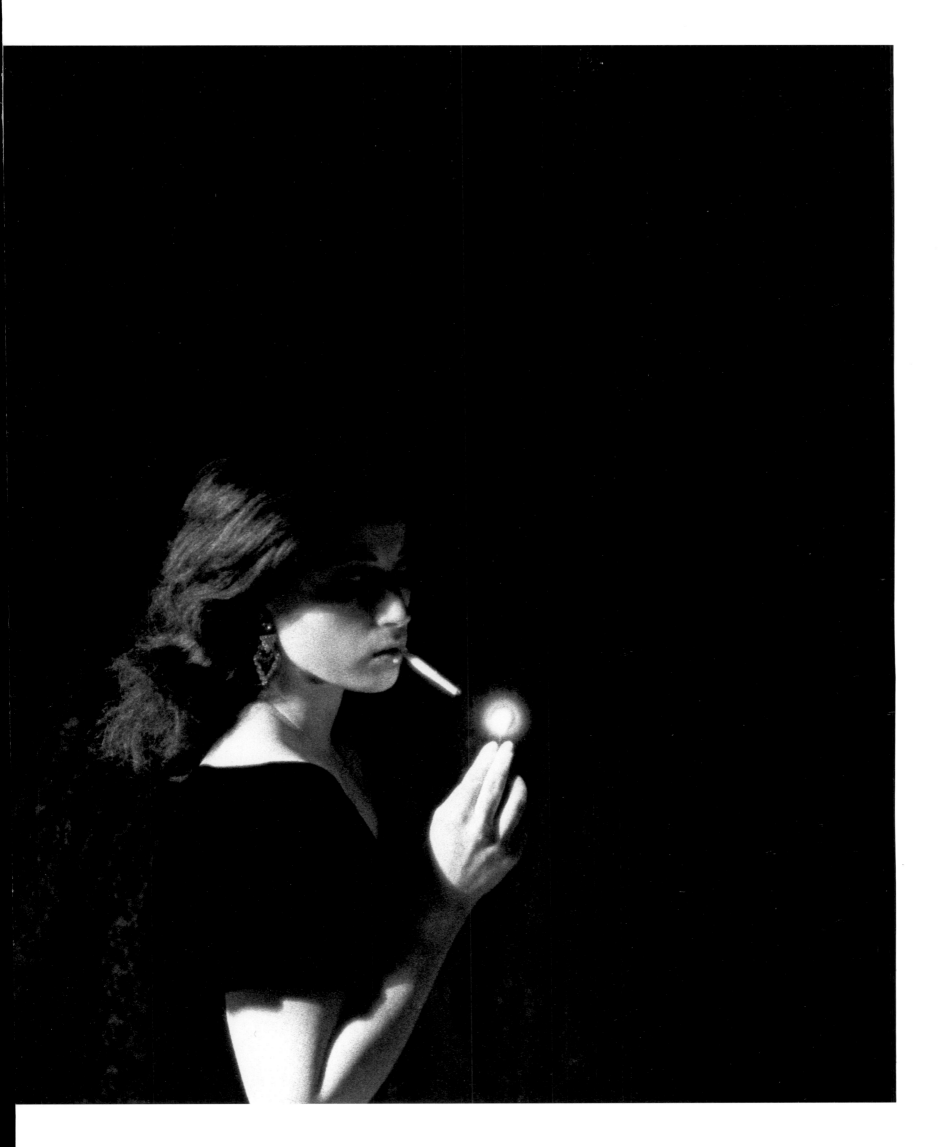

20 Untitled Film Still # 32, 1979

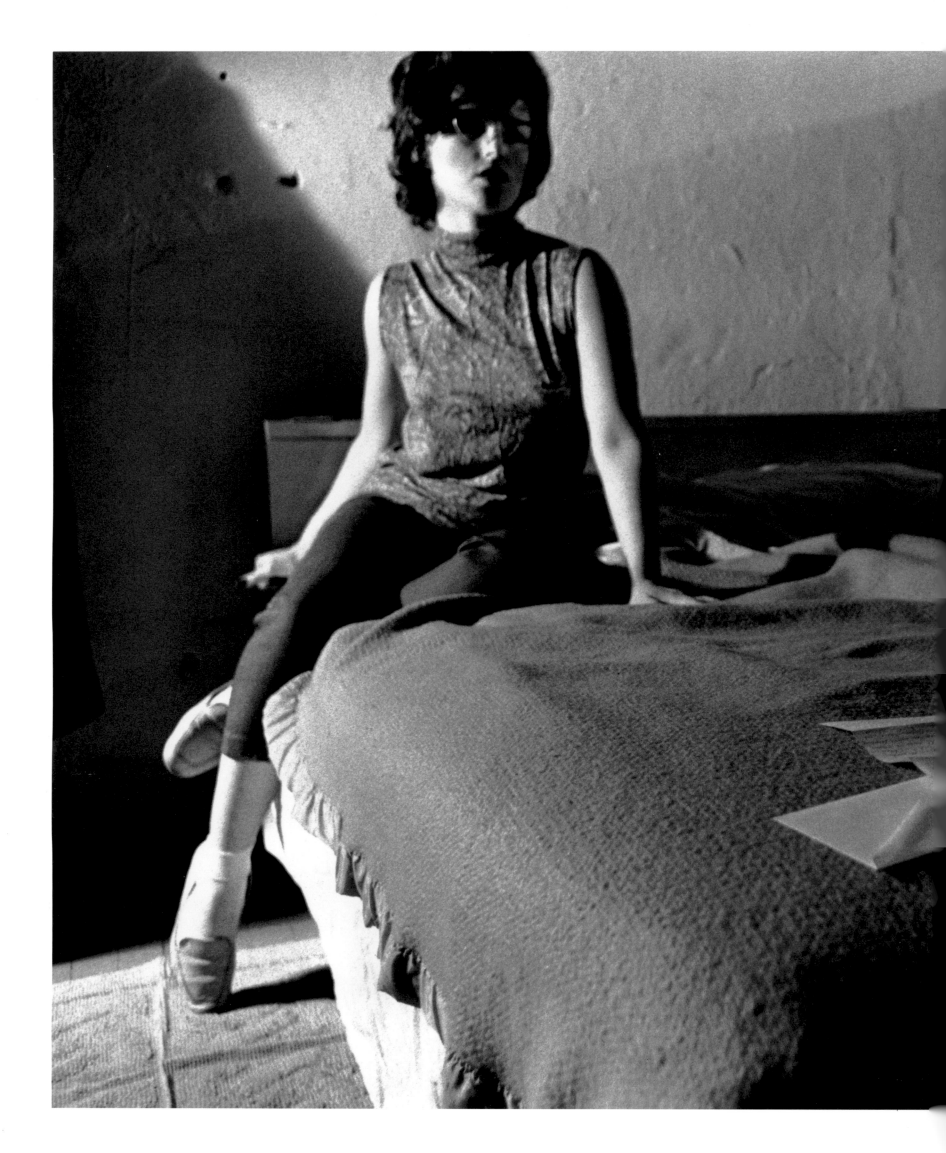

21 Untitled Film Still # 33, 1979

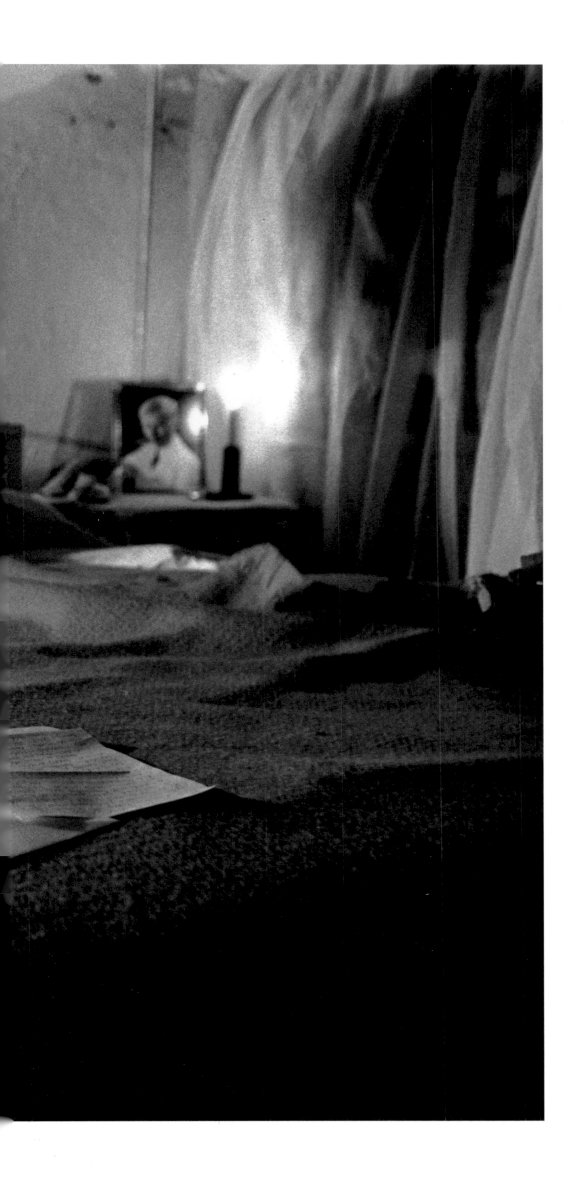

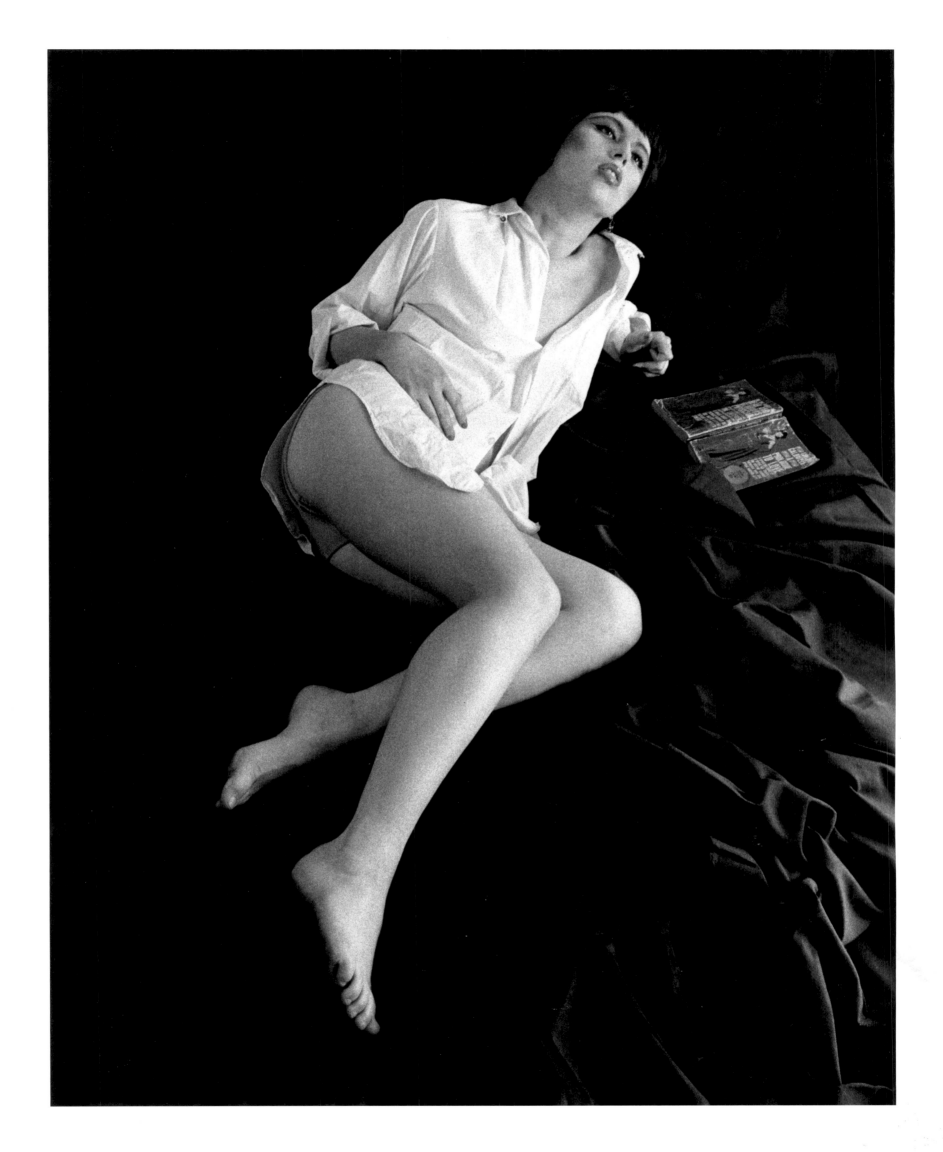

22 Untitled Film Still # 34, 1979

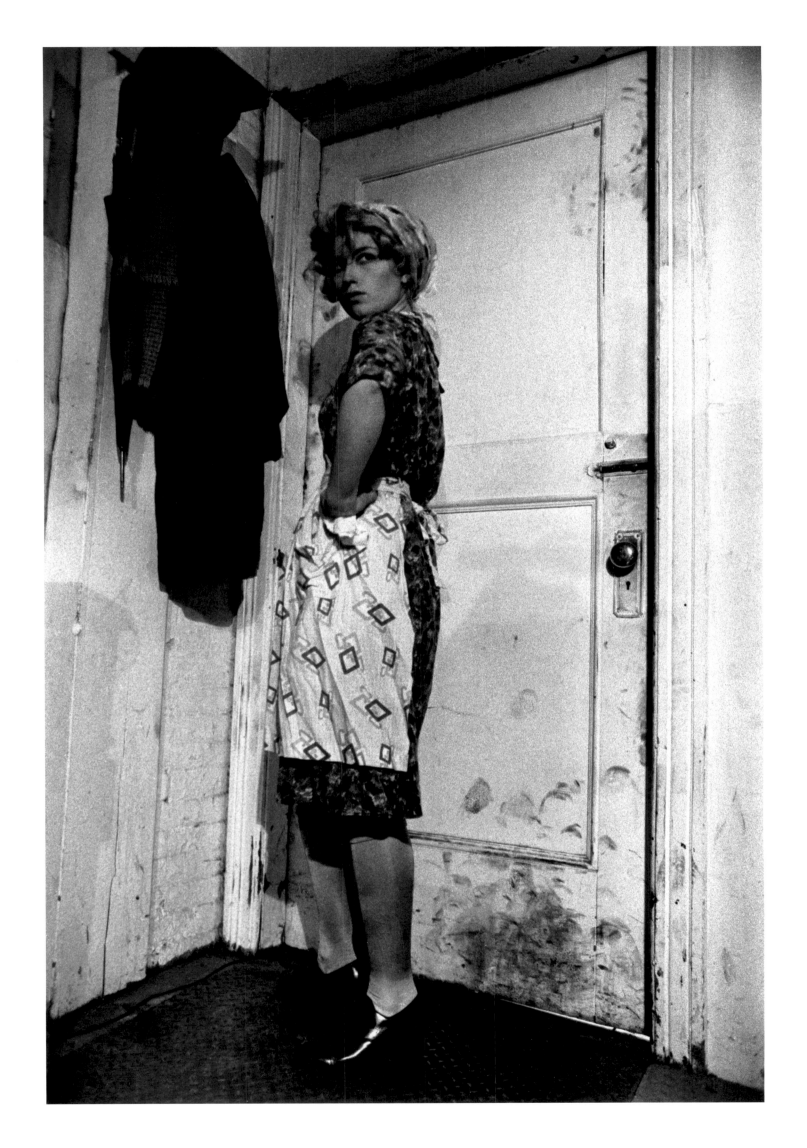

23 Untitled Film Still # 35, 1979

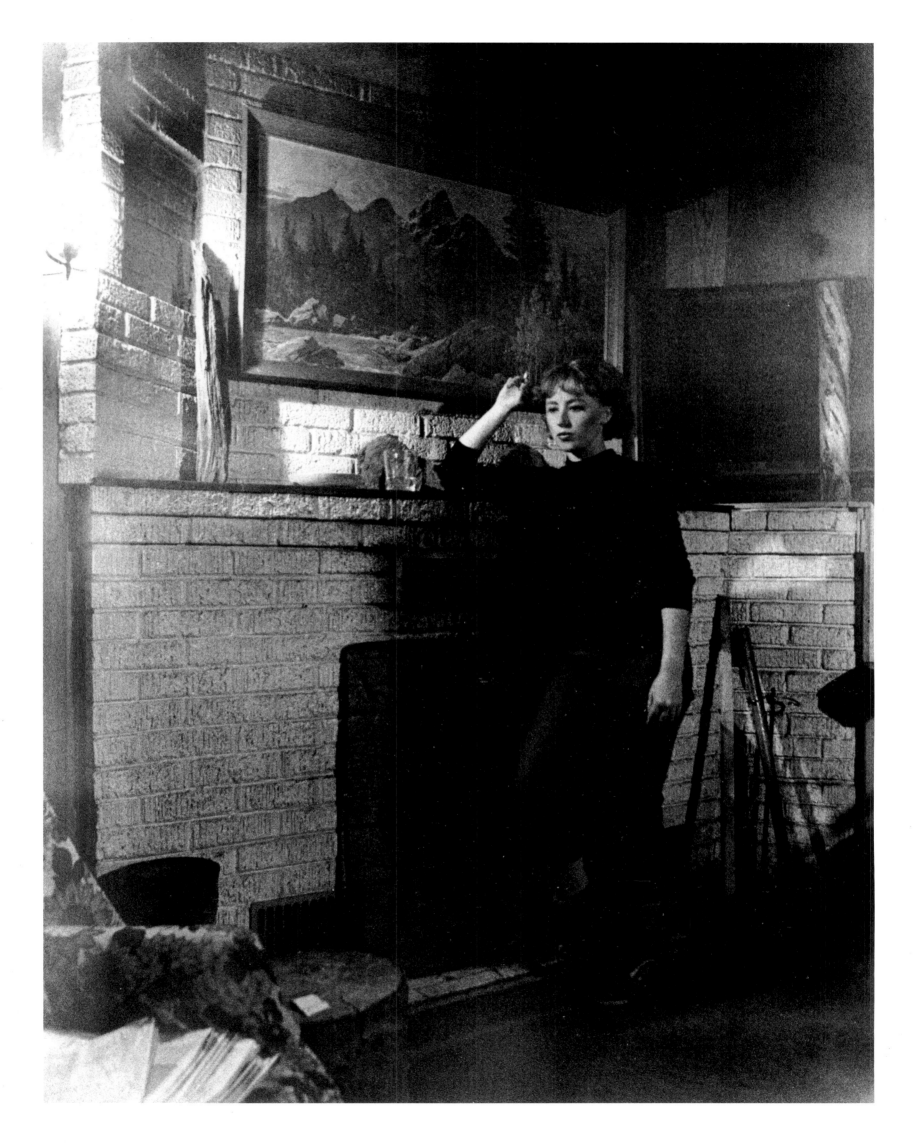

24 Untitled Film Still # 37, 1979

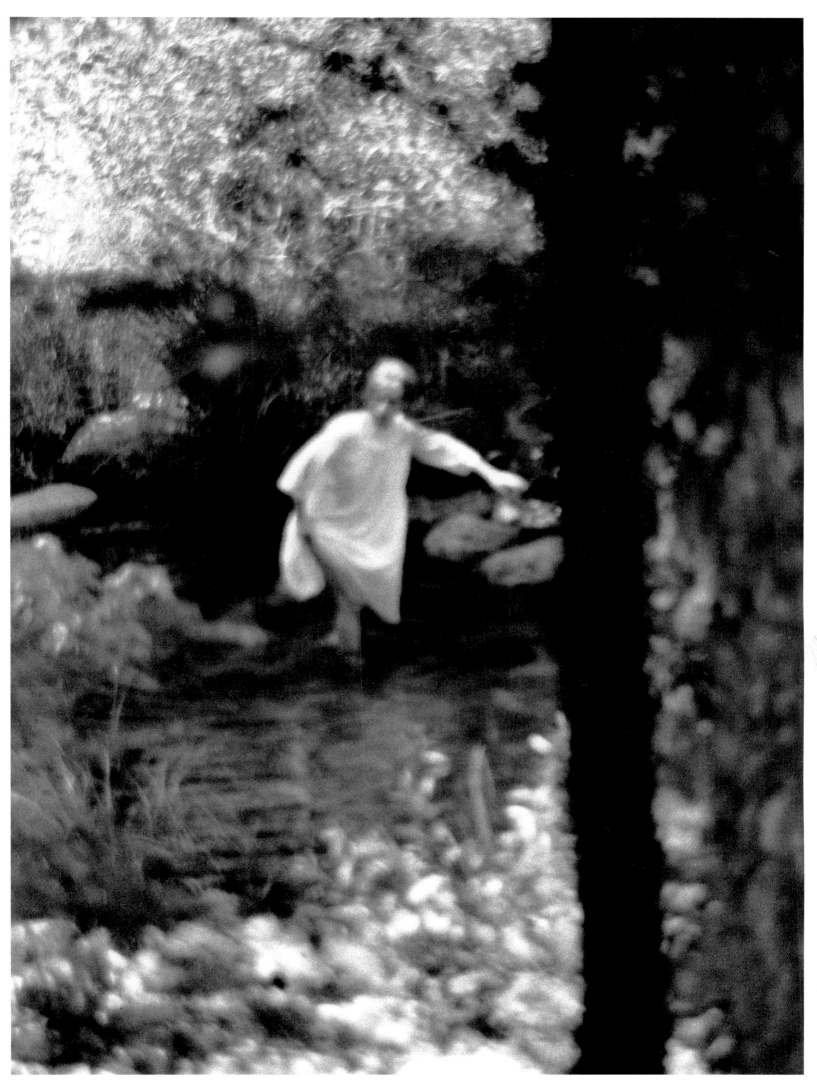

 25 Untitled Film Still # 38, 1979

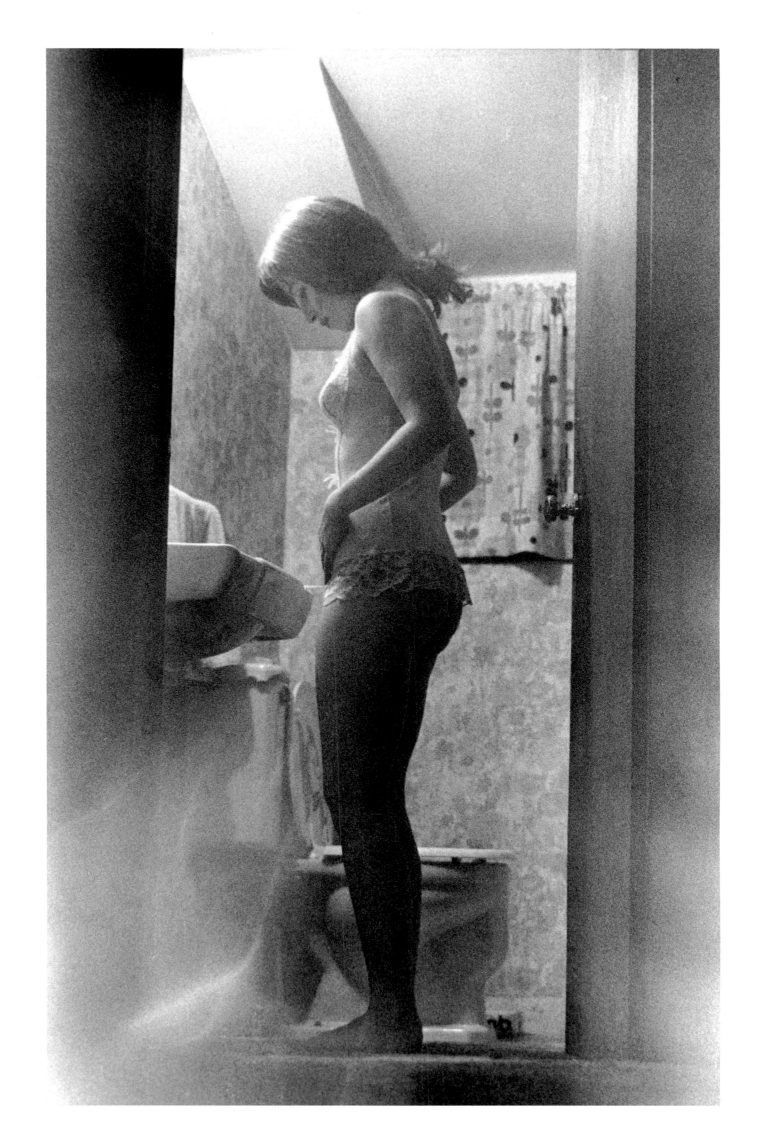

26 Untitled Film Still # 39, 1979

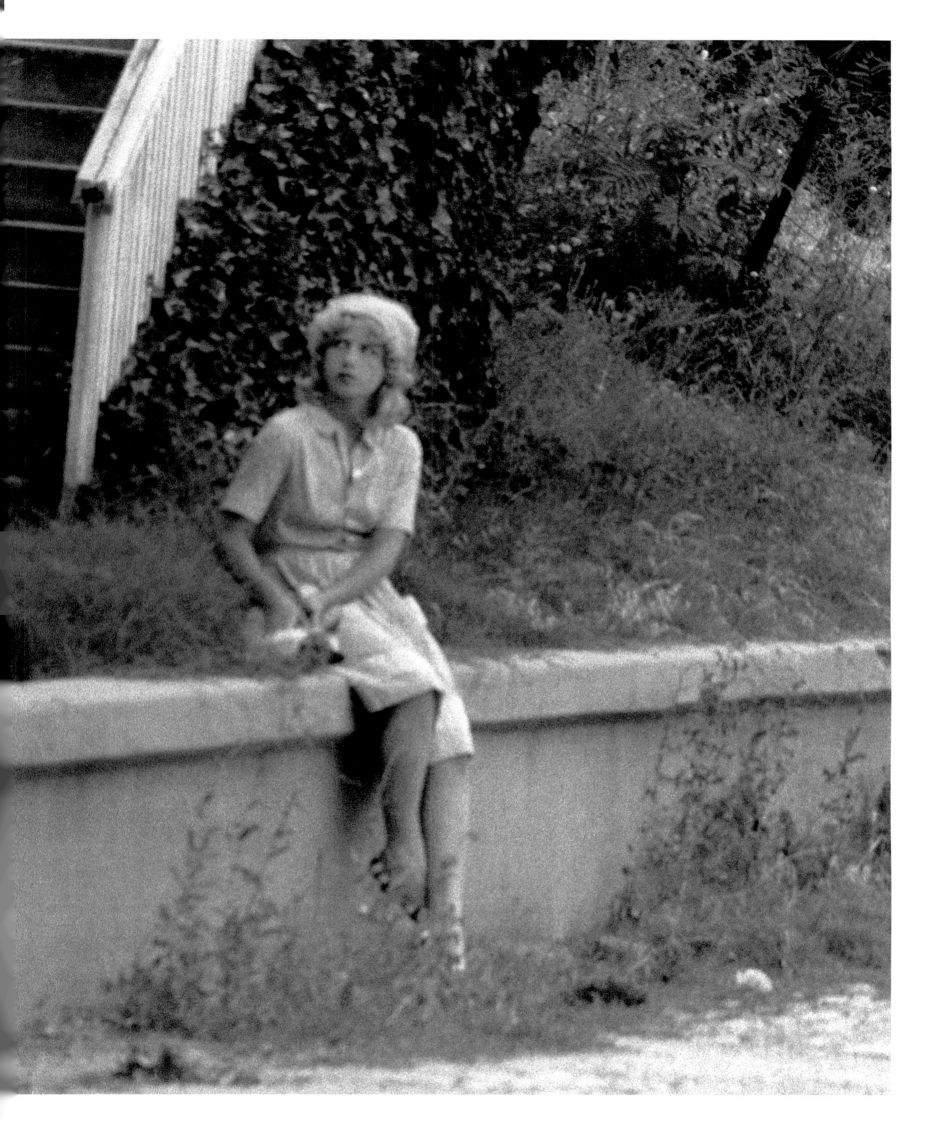

27 Untitled Film Still # 40, 1979

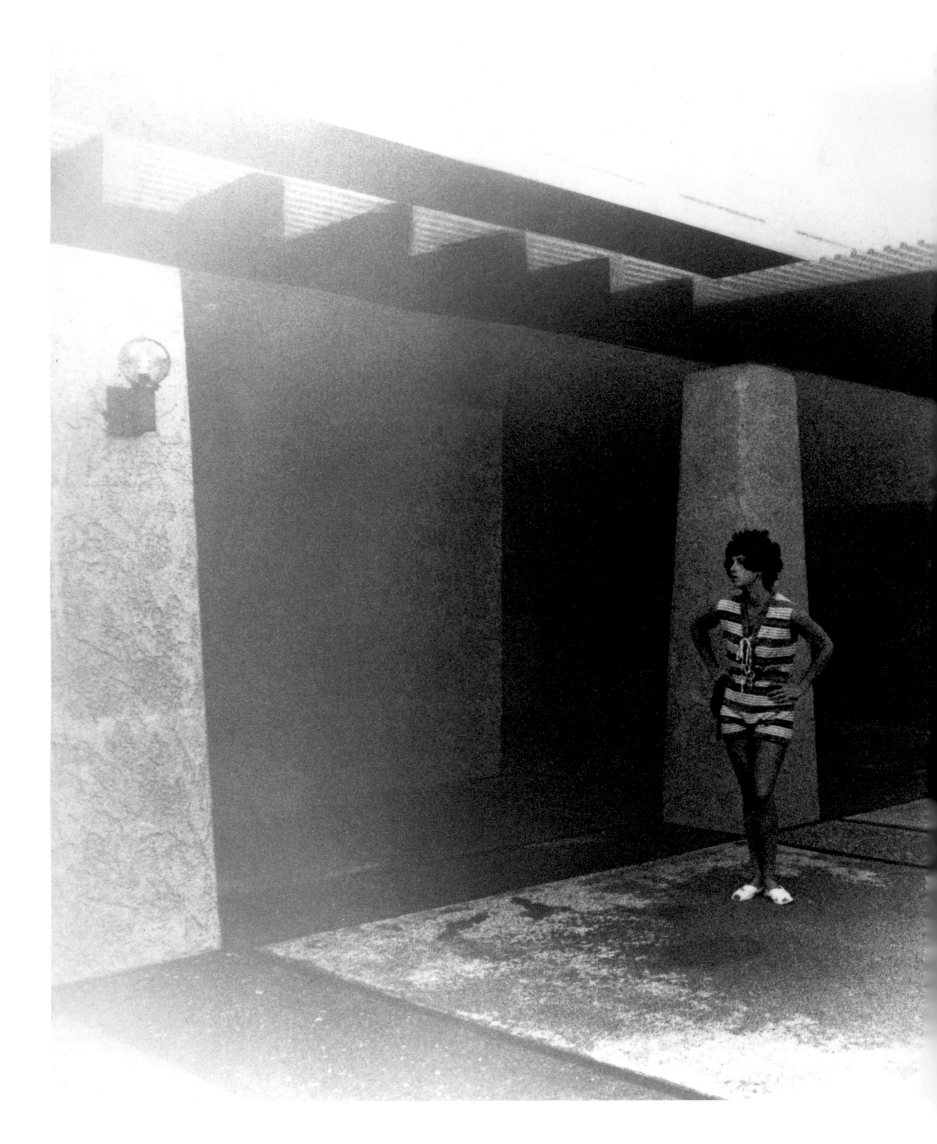

28 Untitled Film Still # 41, 1979

29 Untitled Film Still #43, 1979

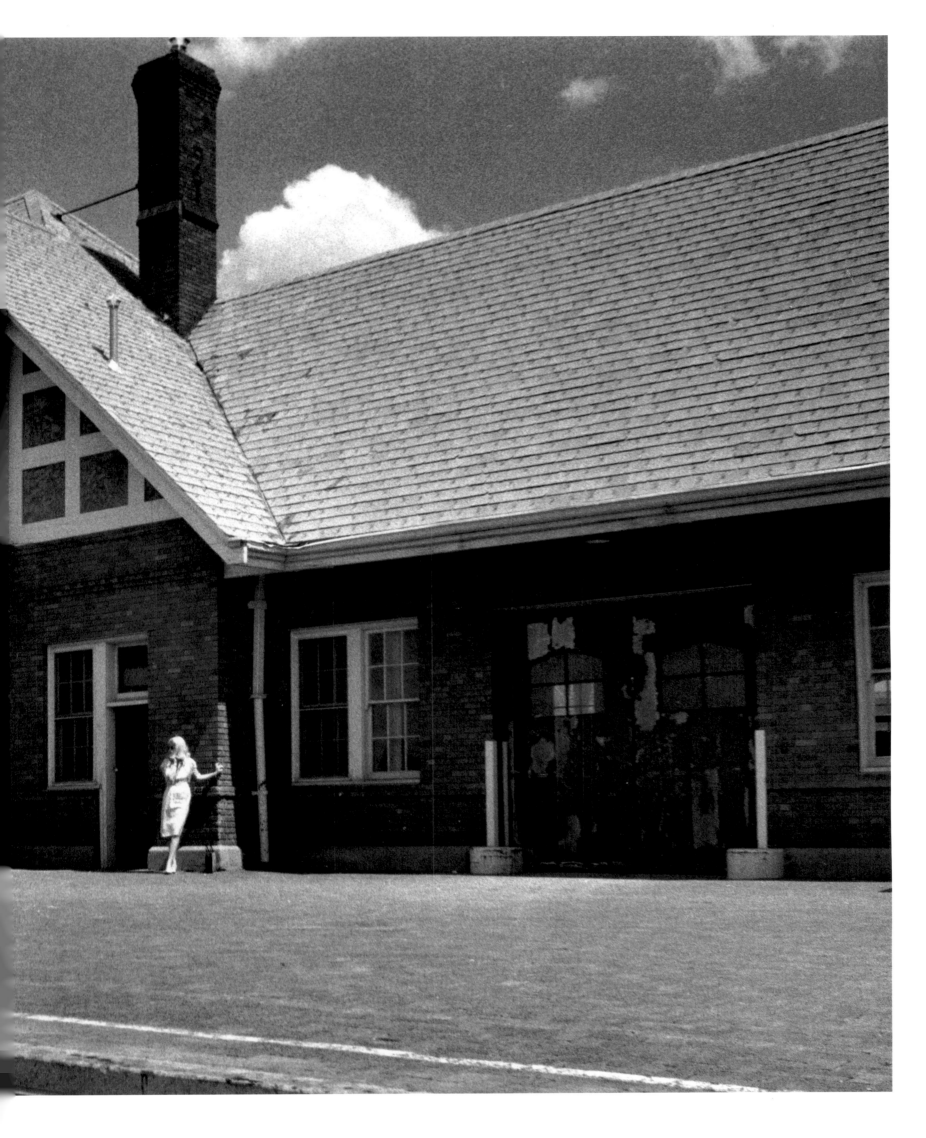

30 Untitled Film Still # 44, 1979

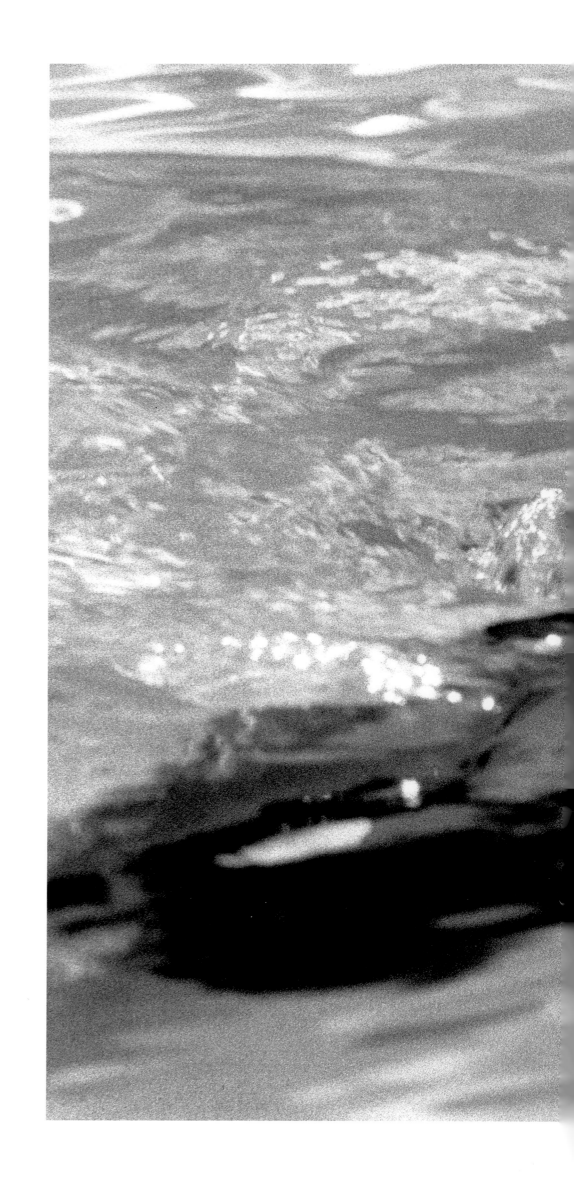

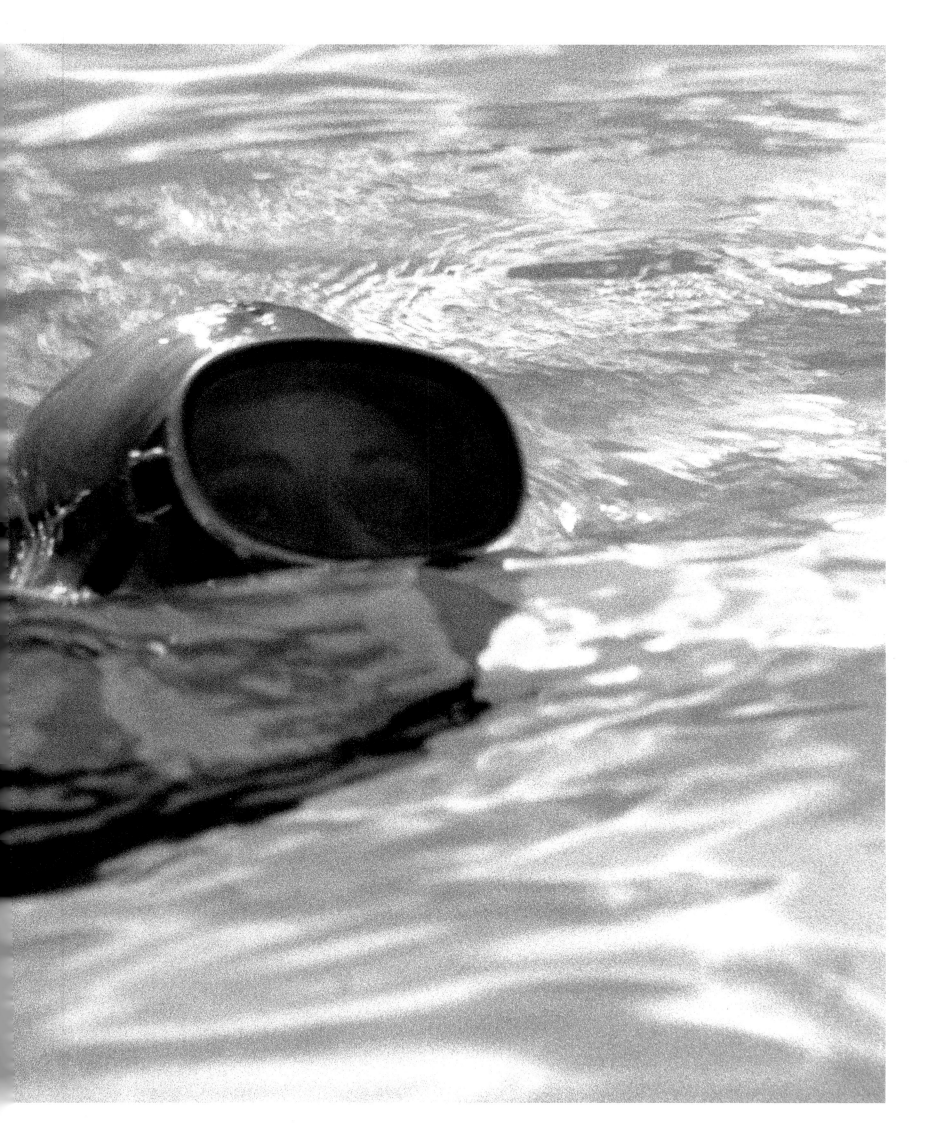

31 Untitled Film Still # 46, 1979

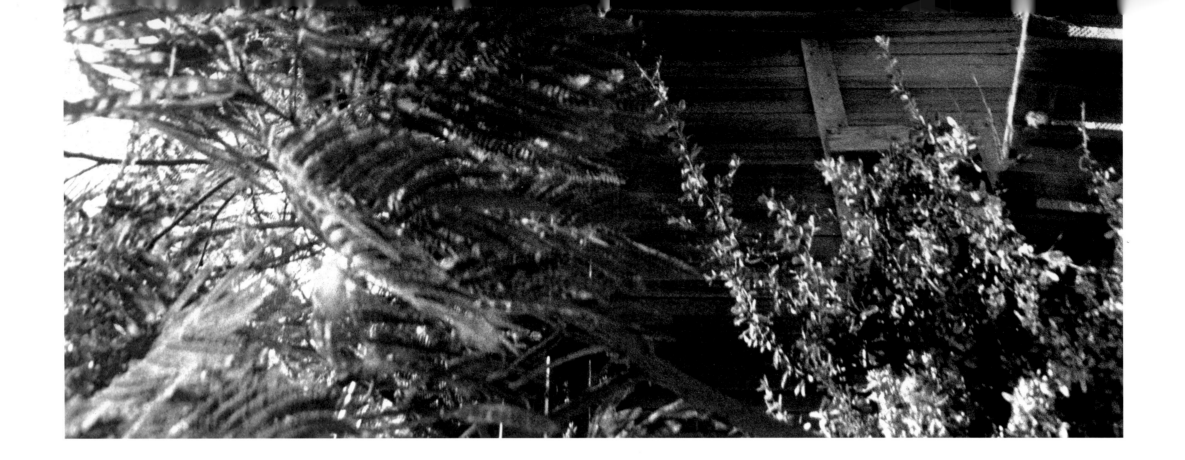

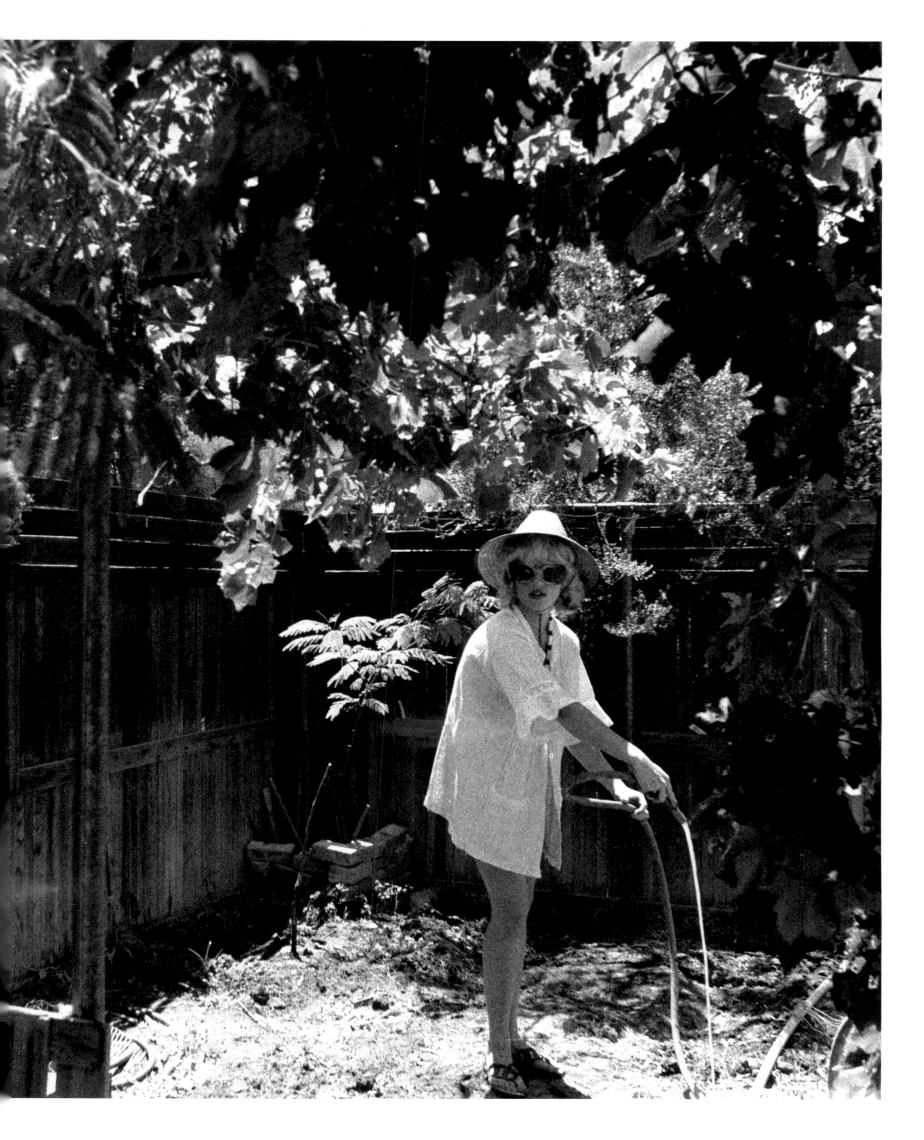

32 Untitled Film Still # 47, 1979

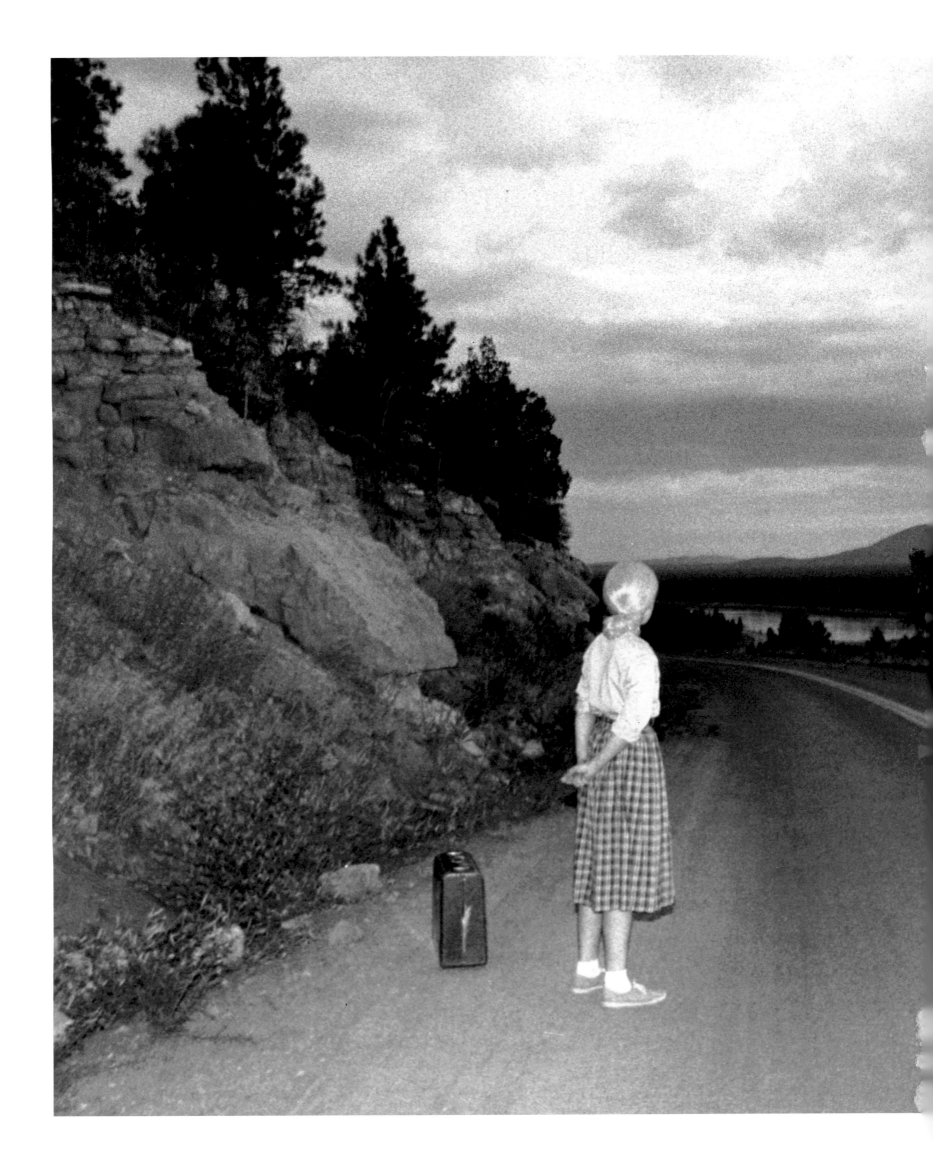

33 Untitled Film Still # 48, 1979

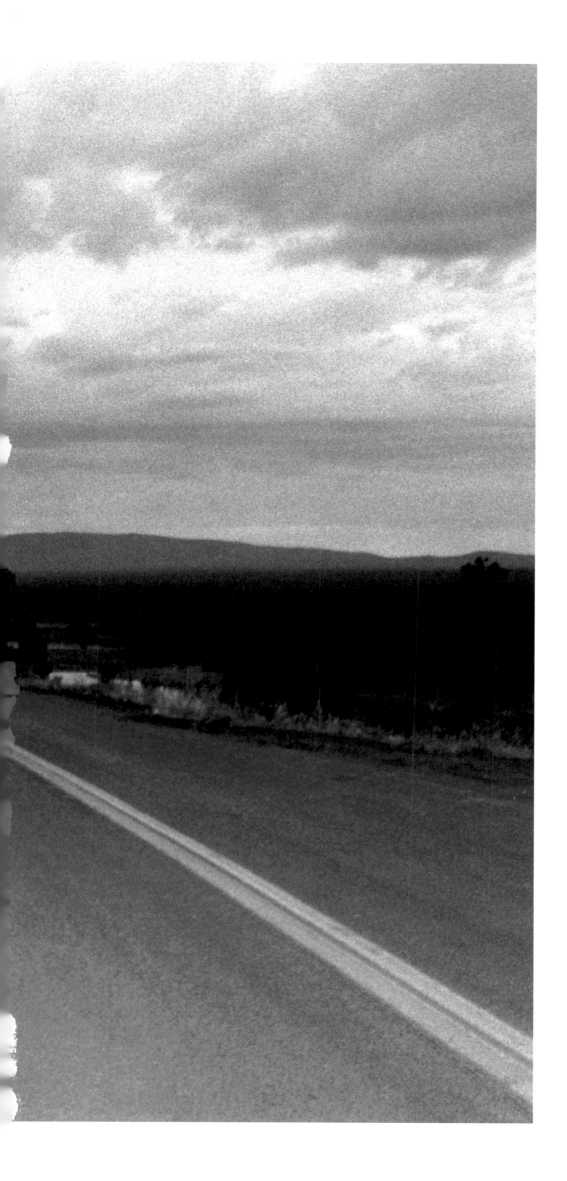

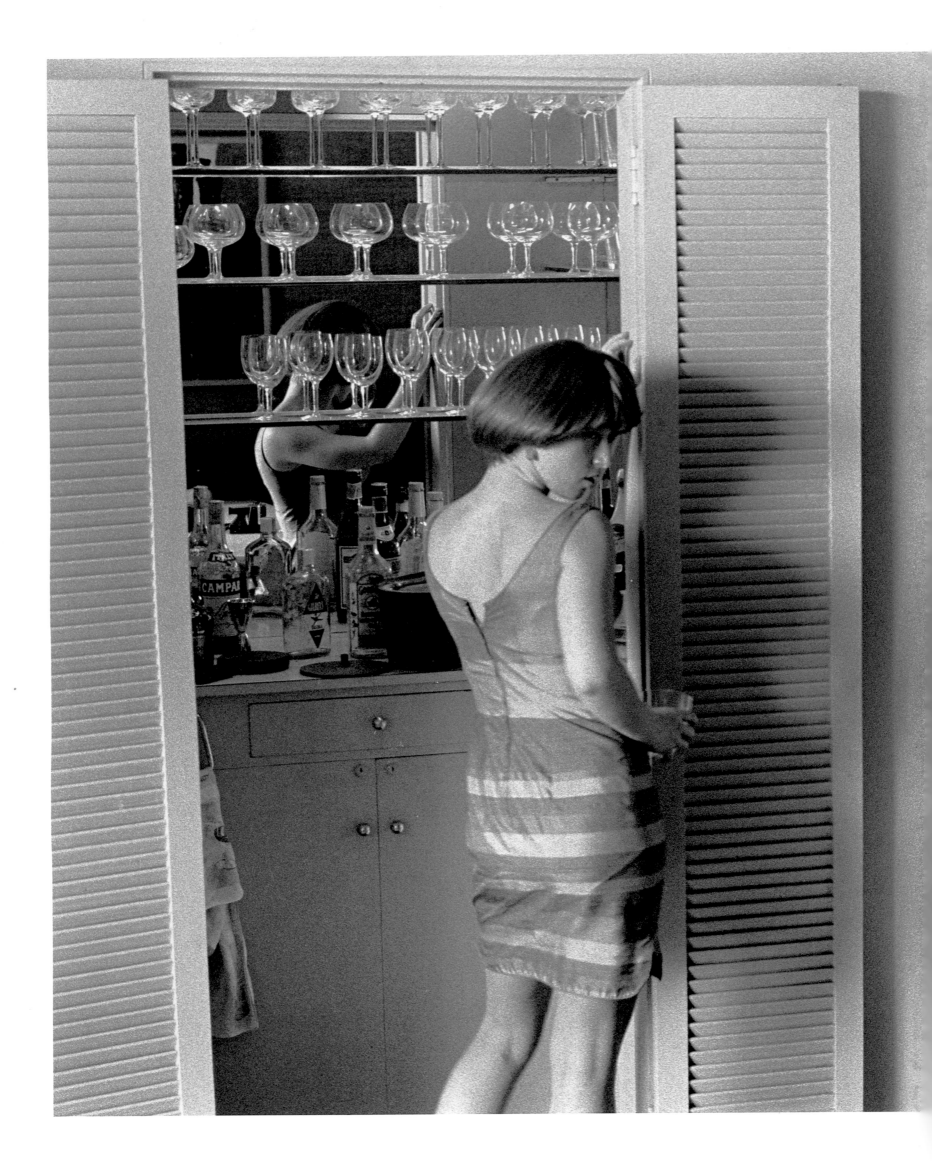

34 Untitled Film Still # 49, 1979

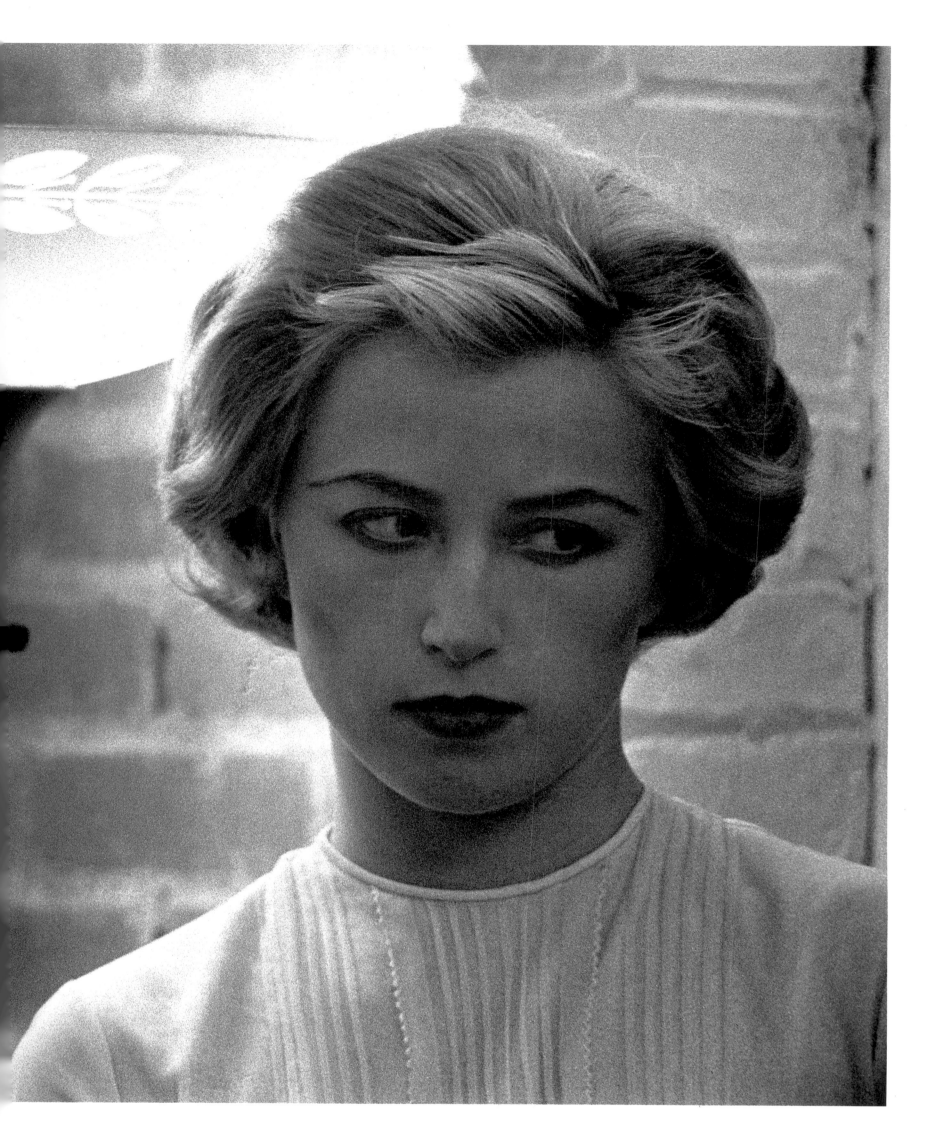

36 Untitled Film Still # 53, 1980

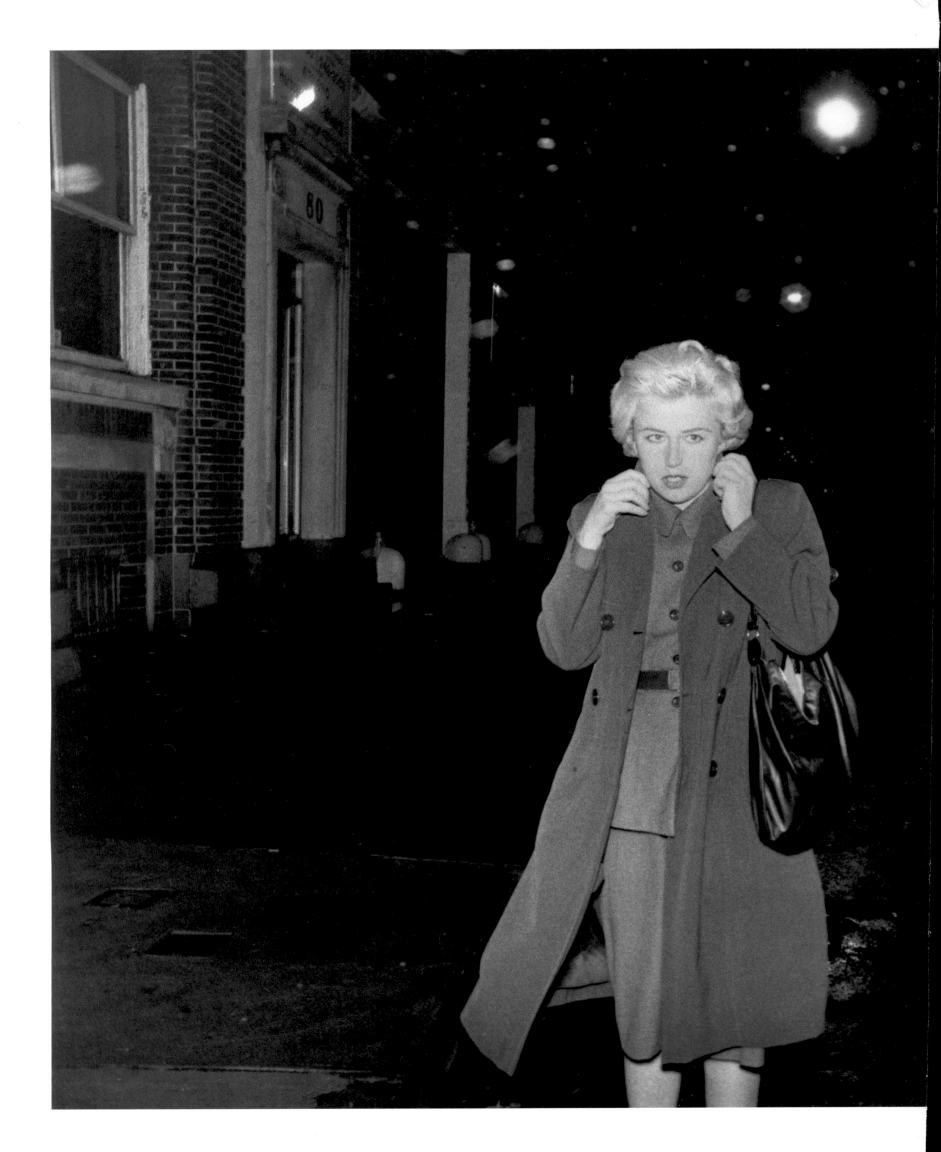

37 Untitled Film Still # 54, 1980

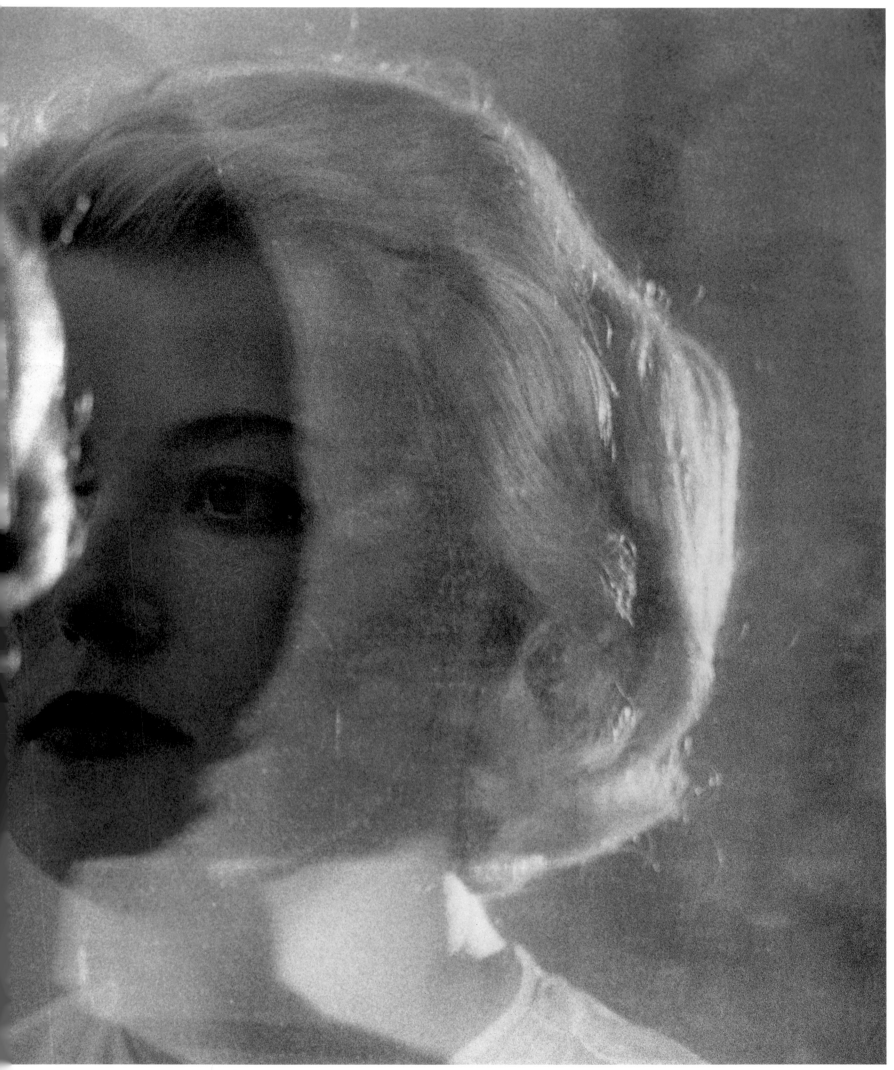

38 Untitled Film Still # 56, 1980

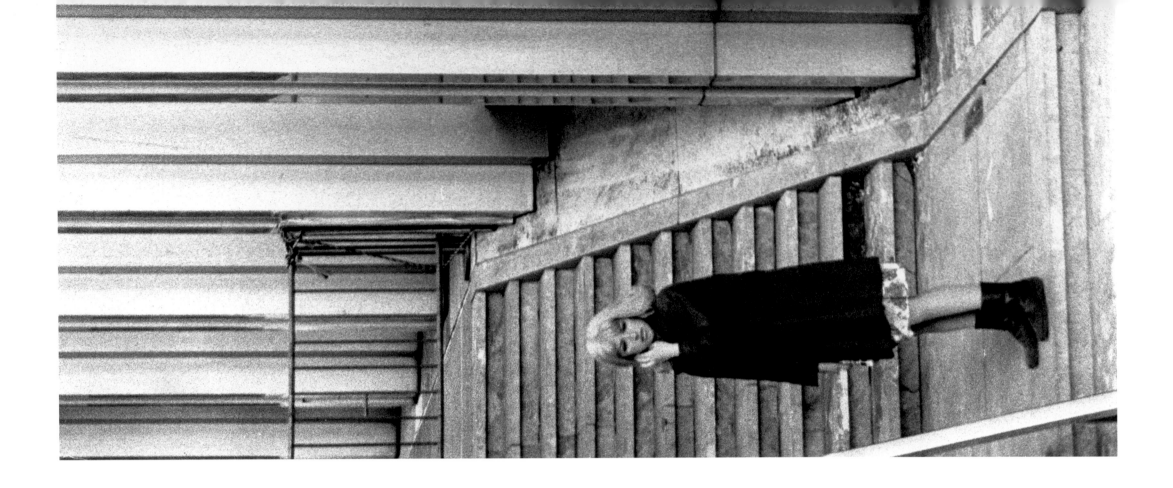

39 Untitled Film Still # 63, 1980

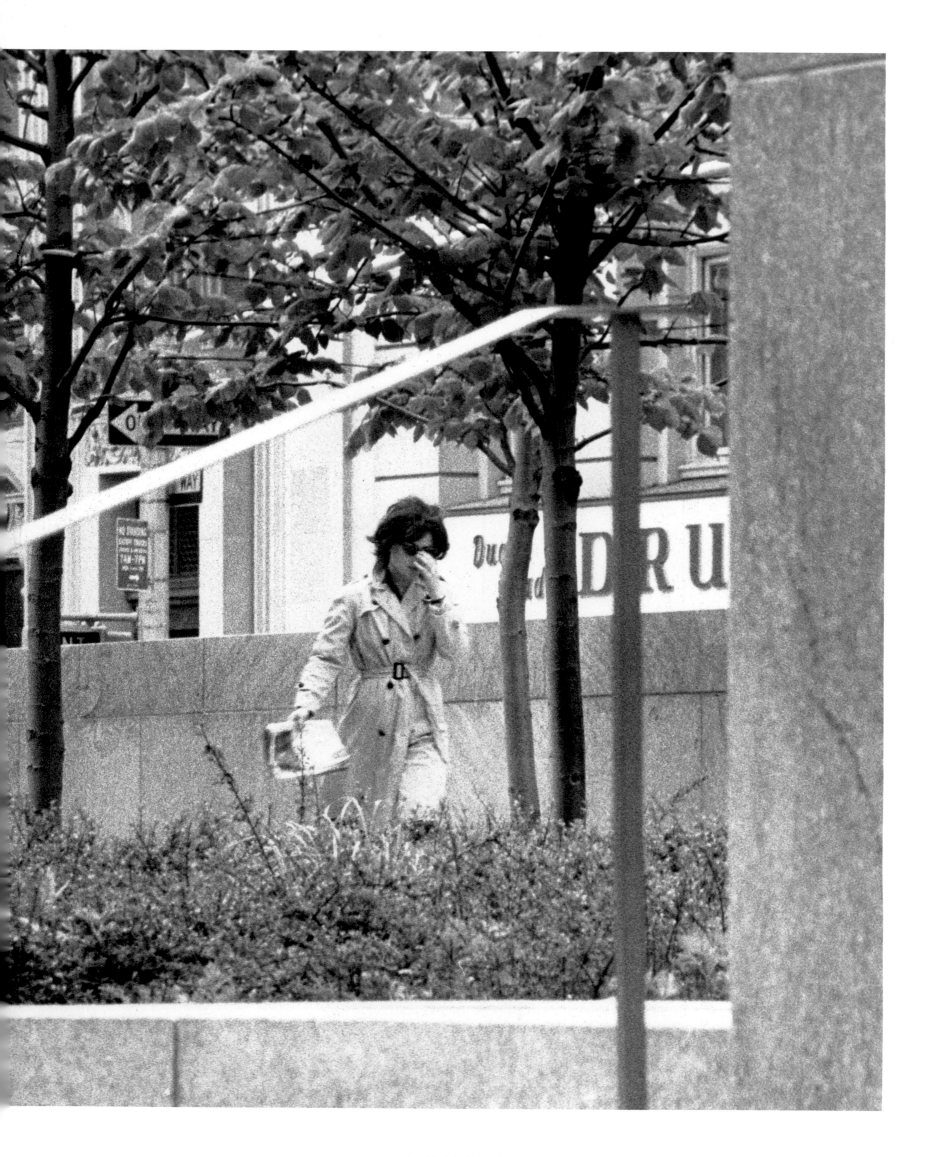

40 Untitled Film Still # 83, 1980